IMAGES
*of America*

# COOS COUNTY

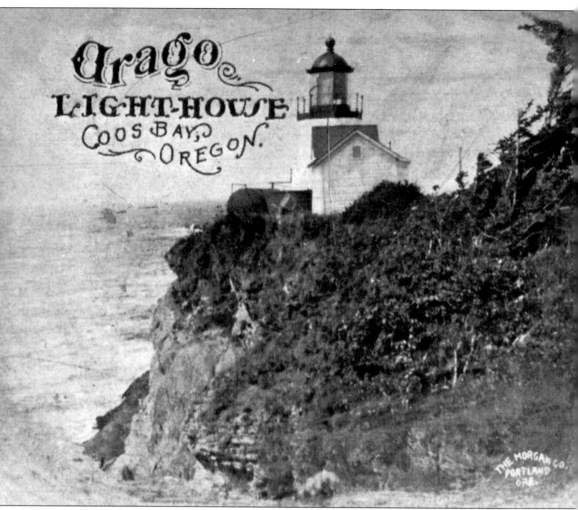

**Arago Light-House Coos Bay, Oregon.**

Perched at the exposed western edge of Cape Arago on an islet known as "Lighthouse Island" or "Chief's Island" for its historical associations with local Coos Indians, Coos Bay's first lighthouse struggled to survive against the winds and rain. Left to decay, the building was replaced, first in 1909 and then in 1934, when it was finally demolished. Cape Arago is just one of Oregon's treacherous seaside promontories where ships have wrecked and lives have been lost. Such tragic events prompted the construction of lighthouses all along the coastline. (CCHMM 992-8-0623.)

ON THE COVER: In order to accommodate workers who travelled from site to site to earn their wages, the region's lumber companies set up logging camps in the forests around Coos County. Largely home to unmarried men who shared the overcrowded, often unpleasant bunkhouses the camps sometimes included shacks for married men and their families who were housed in the "family camp." Women could find jobs as cooks and also did menial work at the logging camps. During World War II, they took on additional tasks, including working as whistle punkers. (CCHMM 958-55h.)

IMAGES
*of America*

# COOS COUNTY

Lise Hull

ARCADIA
PUBLISHING

Published by Arcadia Publishing
Charleston, South Carolina

Printed in the United States of America

Library of Congress Catalog Card Number: 2007923842

For all general information contact Arcadia Publishing at:
Telephone 843-853-2070
Fax 843-853-0044
E-mail sales@arcadiapublishing.com
For customer service and orders:
Toll-Free 1-888-313-2665

Visit us on the Internet at www.arcadiapublishing.com

*To my father, Harold K. Ewald Jr.*
*It wasn't time.*

# CONTENTS

# ACKNOWLEDGMENTS

This project could not have been completed without the gracious assistance of the staff at the Coos County Historical and Maritime Museum, North Bend, who provided all of the images in this book, except where otherwise noted. My deep appreciation goes to Vicki Wiese, collections manager, and to Hannah Contino, museum assistant, for not only providing the images and allowing me to access the museum's fascinating database, but also for being so patient with my numerous questions and requests. They made my journey through Coos County's history a thoroughly enjoyable adventure.

Thank you also to Stephanie and Thomas Kramer, as well as to Tom Baake and Frank Walsh, who so generously contributed photographs to the book. This book was truly a collaborative effort.

I would also like to thank Don Ivy, cultural resources officer, Coquille Indian tribe; Pat Solomon, archivist, Oregon Department of Transportation History Center; Cheryl Crockett, General Tourist Information and Visitor Center coordinator, Bay Area Chamber of Commerce; and Steve Means, director, Coos County Fairgrounds Museum, for willingly answering my questions. They opened doors into the past and brought it into the present, which is, after all, what makes history so precious.

And finally, I would like to thank Julie Albright, Northwest editor for Arcadia Publishing, for her enthusiasm and support and for promptly responding to my countless messages as I explored Coos County in photographs and on foot.

My trek through Coos County's history has made me so much more aware of the rich documentary and cultural resources that exist here. Tangible traces of this past survive in the towns and countryside. They are well worth seeking out; we just need to take the time to look for them. Who would have known, for example, that the rotting timbers of the *Roosevelt*, the old ferry that shuttled folks across Coos Bay, can be found along Isthmus Slough? One can just imagine what other relics survive along the county's waterways and back roads. In so many ways, historic photographs are our keys to unlocking the past.

# INTRODUCTION

First encountered but bypassed by Spanish and British explorers in the 16th century, Coos County was reputedly visited by Sir Francis Drake in 1579. White settlement of the area began shortly after the *Captain Lincoln* wrecked on the north side of the treacherous Coos Bay bar in January 1852. The survivors established Camp Cast-a-Way, the presence of which sparked the curiosity of settlers from nearby areas, including Patrick and James Flanagan, who came just to visit the camp but then decided to settle at Coos Bay themselves.

Coos County's combination of natural resources and coastal environment made it the ideal destination for 19th century pioneers seeking a "paradise" and new opportunities. Scores of their descendants still populate the area. Thick forests, lush floodplains, an extensive network of waterways filled with fish that led to the Pacific Ocean, and the existence of the largest deep draft port between Seattle and San Francisco primed the region for development. Roadways such as the Coos Bay Wagon Road connected the bay area to central and southern Oregon, and the ports at Coos Bay and Bandon connected Coos County to the rest of the world. Today the Port of Coos Bay remains one of the world's leading shippers of forest products.

Named for the Coos (Coosan or Kusan) Indians, the county's name has been translated as "lake" and "place of pines." Sporadic skirmishes between the Native American groups and white strangers began when the first miners and fur trappers wandered the region in the 1820s and 1830s. European diseases, such as small pox, decimated portions of the Native American population. For the most part, however, relations remained peaceful until the wagon trains appeared during the 1850s. Raiding finally exploded into violent large-scale warfare and culminated in the Rogue River Indian Wars of 1855–1856, after which many native families were removed to reservations. Those that remained behind contributed significantly to the burgeoning economy by working in the mines, logging the forests, and in other capacities.

The 1850s was in many ways the boom decade for Coos County, which was officially established in 1853. In 1852, two Native American prospectors discovered gold near the mouth of Whiskey Run Creek, south of Coos Bay, and a new gold rush began. Miners flooded the spot, and a small town named Randolph appeared nearly overnight. Almost simultaneously, shipping, logging, milling, shipbuilding, and farming (including dairy and cranberry farms) took hold of Coos County, and many pioneers became successful entrepreneurs, such as Asa Simpson and Henry Luse, who made their fortunes in shipbuilding and logging, and Patrick Flanagan, who opened a coal mine at Newport, later renamed Libby.

Pioneers from all walks of life journeyed to the area. Many came in groups, settlers who rode wagons across America from such bases as North Carolina and Baltimore. Many simply came for a new beginning and discovered success at such efforts as logging or dairy farming. Many of their descendants still own and work the same properties. Some pioneers emigrated from Ireland, such as Lord George Bennett, from Bandon, Ireland, who not only brought golden gorse to the region in

the 1870s and helped establish the town that became Bandon, Oregon, but who also observed:

> To your foes' desires, there are thorns and briars,
> For to tear you on your track,
> With your flesh in tags, all your clothes in rags,
> And the skin torn off your back.
> I hereby assert, if you don't find hell,
> 'Mongst the logs, in the mud and the mist,
> I vow and declare, and I'm willing to swear
> That such a place doesn't exist.

Laments such as Bennett's failed to deter other settlers from overseas, who came from Scandinavia, Germany, Scotland, and England.

Settlement largely centered on the entrance to Coos Bay, where the earliest communities, Empire City (the original county seat), Marshfield, and North Bend, sprang up. Today Coos Bay and North Bend incorporate the three communities and have a combined population of over 25,000 people. A few Victorian-era homes still decorate the two cities, and simple cottages distinguish original neighborhoods, which overlook giant ships that transport wood products to both domestic and international destinations.

Towns such as Powers, Libby (Newport), Parkersburg, Riverton, Randolph, and Beaver Hill were, out of necessity, built farther away from the bay. Many of these communities housed the men and their families who labored in the mines, shipyards, and forests. Several, such as Bandon, Coquille, and Myrtle Point, benefited commercially from their riverside locations and access to the sea. Some still survive; others have disappeared completely. In 1898, the county courthouse moved from Empire to the more centrally located Coquille City, where it remains today.

During the 1980s, the Confederated Tribes of Coos, Lower Umpqua, and Suislaw and the Coquille Indian tribe regained their status as federally recognized Native American tribes, having been terminated in the 1950s. The Mill Casino, owned by the Coquille Indians, currently employs over 600 people and contributes in a variety of ways to the local economy. The most recent big player to arrive on the scene is the Bandon Dunes Golf Resort, which employs over 400 residents from the bay area and elsewhere, and is ranked in the top 10 of the nation's golf resorts. Even with these developments, the region remains largely rural and in many ways is unaffected by the changing times.

Coos County's strength is its constancy. Life on the south coast has remained surprisingly consistent, despite modernization, technological change, and the influx of tourists. Neither fire nor drought nor flood has altered the temperament of the people. It's an attitude with historical origins founded in a sense of place—a feeling of satisfaction that keeps the people tied to the area and to their own community.

# One

# SETTLEMENT AND THE EARLY YEARS

The wreck of the *Captain Lincoln*, a steam schooner, in 1852 led to the establishment of Camp Cast-a-Way on the North Spit and brought curiosity seekers, such as pioneer Irishmen Patrick and James Flanagan, James Maxey, Edward Breen, and Peter Johnson, to the region. Today a discreetly located monument marks the spot where the stranded seamen changed the course of local history, sparking the development of the shipping and lumber industries that now characterize Coos County. (Courtesy Frank Walsh.)

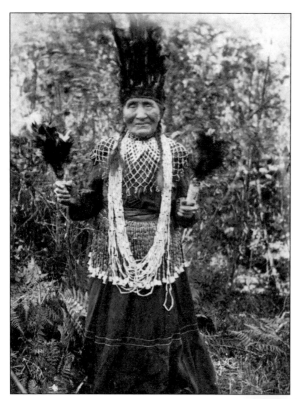

As a result of the vagaries of the Rogue River Wars, the subsequent removal of Native Americans to the coast reservation, and then termination, a significant portion of people who had Coquille ancestry also had Coos Indian ancestry. In some ways, the Coquille identity became subsumed via various documents and reports referring to the "Coos Indians," the "Coos Bay Indians," or the "Indians of Coos Bay." Nonetheless, the "Coquilles" were and are in fact a discrete group, as witnessed by three treaties in 1855, the U.S. Court of Claims record of 1940–1946, and the termination of the tribes and bands of Western Oregon in 1954–1960. Here two Coos Indians, Old Blind Kate and Chief Daloose Jackson, display traditional Native American attire. (CCHMM 95-D184 and CCHMM 975-73I-a.)

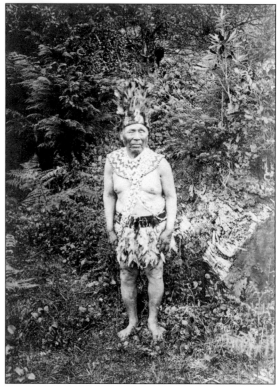

The arrival of white explorers and settlers had a dramatic impact on the lives of the Coos Indians. Not only did smallpox and measles outbreaks in 1824 and 1836 kill a large portion of the Native American population, but they also lost their tribal lands as a result of the Oregon Donation Land Act, which gave free land to pioneers who settled, improved, and filed claims for the property. (CCHMM 959-246s.)

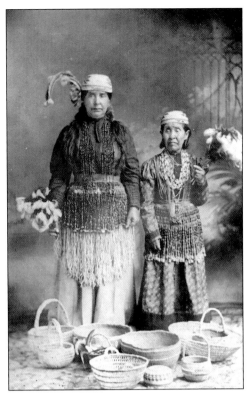

After the Rogue River Wars, Native American residents were sent to the coast reservation. Some evaded removal and remained in Coos County. Many Coquilles today still have both "Coos" and "Coquille" ancestry resulting from the traditions prior to contact with white settlers as well as the circumstances since contact. This image shows Princess Lottie, at Marshfield, in 1904. (CCHMM 963-37.)

11

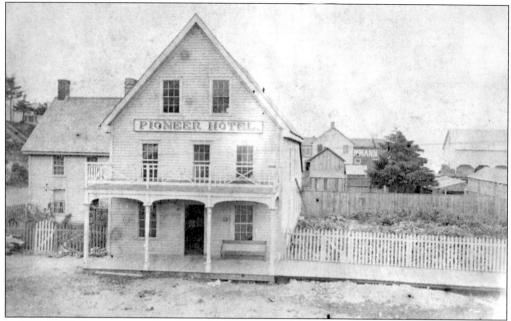

In 1853, W. H. Harris, a member of the Coos Bay Commercial Company, chose the site for Empire City, where he built a cabin and laid out the street plan. The town, which became the county seat, grew quickly and, within two years, had at least 30 houses. Empire soon sported a sawmill, a shipyard, wharf, general mercantile stores, a hardware store, several attorneys, a doctor and dentist, and a school. Several saloons and three hotels also served the locals, including the Pioneer Hotel (seen here), managed by Margaret A. Jackson, and Esther Lockhart's hotel. The wife of Freeman Lockhart, Esther was also a school teacher and the first woman president of the Coos and Curry Pioneer Association. (CCHMM 958-550B and CCHMM 961-128E.)

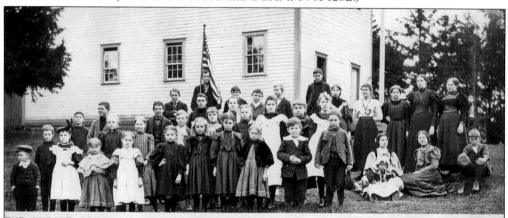

THE EMPIRE SCHOOL IN THE LATE 90'S WAS A ONE ROOM SCHOOL AS THE UPPER ROOM WAS CLOSED. INEZ R. CHASE WAS THE TEACHER. PUPILS WERE - MINNIE MORRIS - FLORENCE GETTY - SUSIE MARSHAL - GEORGINA MARSHAL - HATTIE MARSHAL - IDA WICKMAN - ANNIE WICKMAN - ANNIE JOHNSON - SELMA JOHNSON - RURA JOHNSON - STELLA JOHNSON - FLOSSIE ERICKSON - BIRTIE ERICKSON - MAY WILLIAMS - ELSIE HALL - ALPHA WICKLUND - STELLA WICKLUND - LILLIE KLAHN - NETTIE MORSE - GEORGINA HAYES - RENA LENNON - SYDNEY KLAHN - JAMES MAGEE - CHARLES MAGEE - WILLIAM MAGEE - DAVID MORGAN - ARTHUR MORGAN - CHESTER MORGAN - ARTHUR GETTY - NEIL GETTY - ELTON METLIN - EVERETT EARL - FRED GETTY - LLOYD LENNON - BIRDIE HAYS - WORDIE HAYES - HENRY WICKMAN - JOHNNIE WICKMAN AND MAY MAGEE.

Irishman Patrick Flanagan is one of the county's most notable pioneers. Having first settled along the Umpqua River, he came to Coos Bay to visit with the residents of the newly created Camp Cast-a-Way. In 1854, he and Amos Emerson Rogers began mining coal at Newport. Samuel Stillman Mann took over for Rogers shortly thereafter, and the mine became an immensely successful operation. (CCHMM 981-222.)

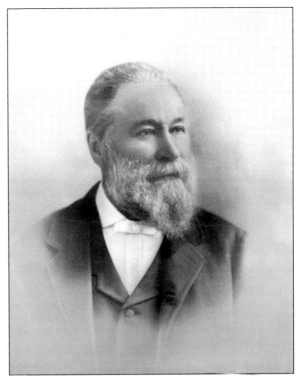

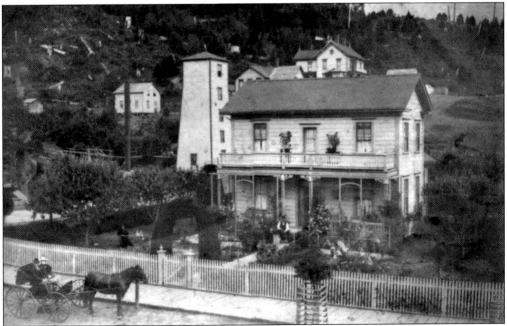

In 1853, the pioneer settlers established the "Coos (Coose) Bay Commercial Company." One of the members was Freeman G. Lockhart, who migrated with his wife, Esther, and staked his claim on the site that became North Bend. Lockhart was active in local politics and served as the county's clerk, school superintendent, and representative to the state legislature. Their home was on Telegraph Hill above the William Deubner house. (CCHMM 978-1.1.)

In 1854, Samuel Stillman Mann not only teamed up with Patrick Flanagan to operate the mine at Newport (later Libby), he also served as the county's first judge at Coos City and Empire, as a U.S. marshal, and as a customs collector. In the 1860s, he married Ella (Elephol) Tower, seen here, Charles W. Tower's sister. (CCHMM 959-289A.)

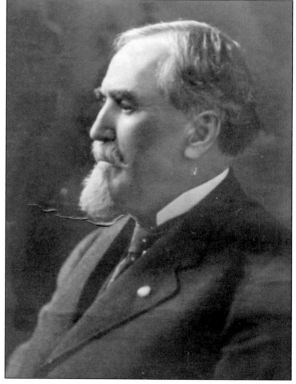

Beginning in 1870, Charles Walter Tower, M.D., provided medical care to residents of Empire and Marshfield. He also operated a drugstore from 1872 to 1880. His son, Isaac, opened the Tower Motor Company in Coos Bay. The present Tower Motor dealership at the southern end of the city owes its origins to the pioneer family. (CCHMM 960-6.)

The county's first water-powered sawmill, the Stacy-Fundy-Wasson mill, was built on the Coquille River in 1853, near the Bullards ferry crossing. It was largely managed by George Wasson, one of the first pioneer settlers in the region. In 1858, Edward Fahy purchased the mill and continued operating the site for several years before passing it to his son, George. This photograph shows Mollie Fahy, George's wife. (CCHMM 975-31.)

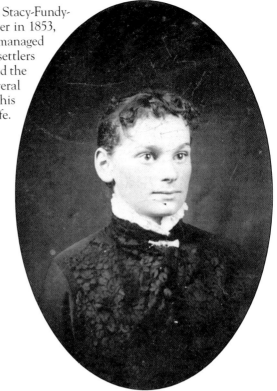

The seasonal and inconsistent nature of employment in the mines and in farming led many of the county's pioneers to work both jobs. Thomas Hirst worked part of the year in the Newport mine but also owned a merchandise store in Marshfield and a house at the corner of North Broadway Street and Alder Avenue, seen here. (CCHMM 992-8-0977.)

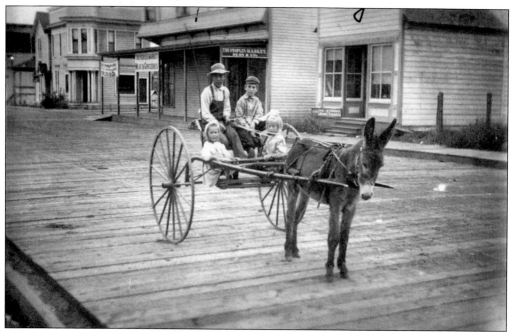

Before the advent of the motorcar prompted the construction of paved roads, coaches, wagons, and carts used dirt or planked roads to get around. Even children knew how to make their way across a town's planked streets by taking charge of vehicles, such as this donkey-drawn cart in early Coquille. (CCHMM 982-241.)

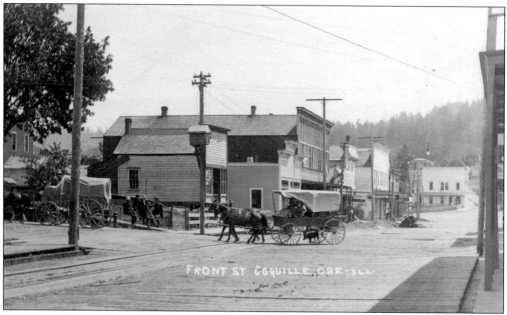

Incorporated as a city in 1885, Coquille's Front Street became its center of commerce in 1871 with the construction of Til M. Vowel's store. Other businesses soon followed: a hardware store, grocery store, drugstores, saloons, mills, and legal and medical offices. A fire devastated the commercial center in 1892, but the completion of the railroad the following year created new business opportunities. (CCHMM 977-101.126.)

Norway, Oregon was founded in the early 1870s by Capt. Olaf Reed (seen here) and Oden Nelson, who named the community after their homeland and established a general merchandise store in 1873. Reed, a former sea captain, also worked with his brother Edward on the construction of the riverboat *Ceres*. His brother Hans operated a shipyard in Marshfield and served for a time as Asa Simpson's master shipbuilder. (CCHMM 981-192.)

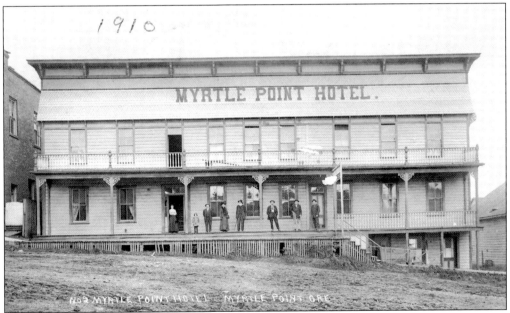

Part of the Baltimore Colony that migrated to Coos County during the 1850s, the Hermann family settled in Broadbent and Myrtle Point. The best-known son was Binger, the area's first paid public school teacher, a lawyer, and a member of Congress. The 50-room Myrtle Point Hotel, which Hermann built in the 1880s, served miners, settlers, and travelers. It was demolished in 1935. (CCHMM 982-191.50.)

Considered too ugly to represent Coos County, Empire City's first courthouse was demolished in 1875. The second courthouse, seen here, was used until 1896, when the county seat moved to Coquille. Judge Hacker's residence stood next to the courthouse. Both structures overlooked Coos Bay. (CCHMM 975-82A.)

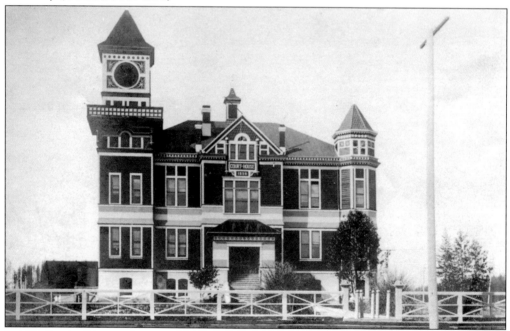

In 1853, Empire City was designated as Coos County's first seat and a new courthouse was constructed to serve that purpose. Forty-three years later, county residents voted to move the county seat to Coquille, a more centrally situated site, and to build a new courthouse. In time, that courthouse, shown in this photograph, was replaced with a more modern structure. (CCHMM 959-280G.)

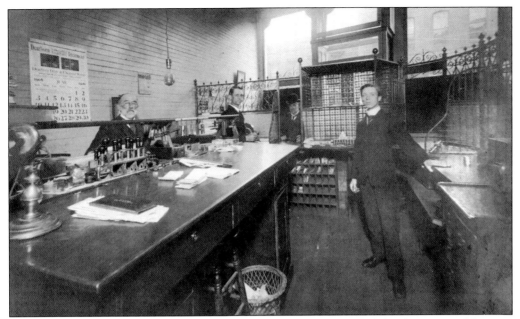

Besides his numerous other ventures, in 1889 Patrick Flanagan founded the Flanagan and Bennett Bank, Coos County's first, with partner Joseph William Bennett, an attorney, who served as the bank's president. Located on Front Street, the bank was destroyed by fire in 1922. From left to right are bank officers Allen Dwight Wilcott; Mr. Swanton, brother of attorney Bennett Swanton; and Robert Swanton, druggist. (CCHMM 968-15D.)

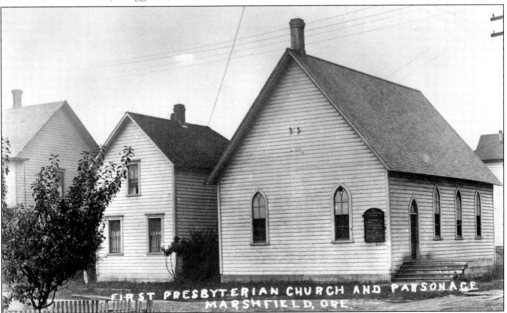

Churches were essential to the county's pioneers. The Barklow family, who settled near Myrtle Point, established the First Church of the Brethren. The group finished their church in 1878. In 1885, the Swedish Lutheran Church of Coos Bay was completed in Marshfield, and the Norwegian Lutheran Church soon followed. The First Presbyterian Church was located at the corner of Fourth and Market Streets in Marshfield. (CCHMM 992-8-1012.)

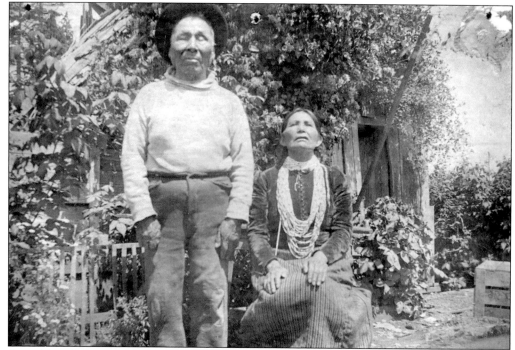

Seated beside her husband, Chief Daloose Jackson, Fannie Jackson wears beaded jewelry and clothing common to Coos Indian women. The half sister of Annie Miner Peterson, the last person known to speak the native Miluk language, Fannie bore 13 children, of whom only the eldest survived to adulthood. (CCHMM 958-509.)

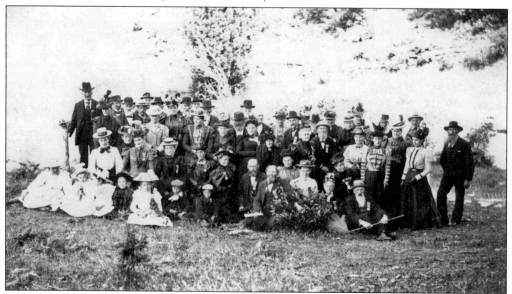

In 1891, the Coos County Pioneer Association formed to celebrate the county's heritage and its pioneer families. Also known as the Coos County Pioneer and Historical Society, it was the forerunner of the Coos County Historical Society, which sponsors the Coos County Historical and Maritime Museum in North Bend. Shown in this image are Mrs. W. D. L. F. Smith, Thomas Hirst, A. D. Wolcott, Mary Marks, Andrew Nasburg, and Mr. and Mrs. Cathcart. (CCHMM 987-P6.)

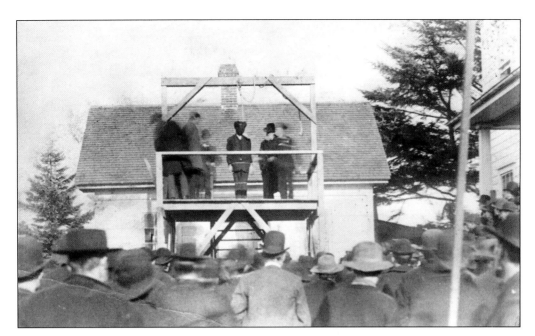

For years, Empire was a focal point of Coos County. The county courthouse conducted business and doled out punishment as necessary from the spot. A U.S. customs house was located in the city, and the Luse sawmill and shipyard were major fixtures. Empire also had a liquor store operated by John Flanagan and hotels, such as the Pioneer Hotel (below), where Coos Indians regularly met to discuss tribal matters. During the 1920s, Louis Simpson and several associates decided to revamp the then-aging city, and Empire was reincorporated in 1928. The population increased and, during World War II, the sawmill experienced a substantial increase in business. Notable among Empire's residents was Dr. Charles Tower, whose fine home still survives close to the waterfront. (CCHMM 987-P1 and CCHMM 992-8-0795.)

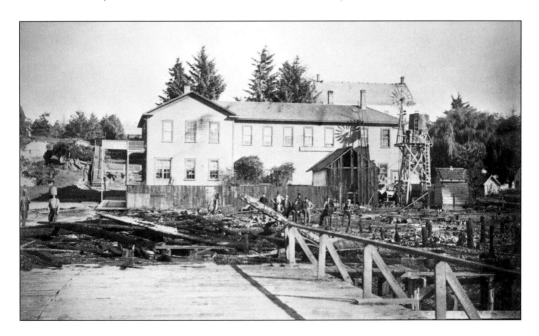

Expectations were high for the development of Empire into a thriving and prosperous waterfront city. In 1882, the Southern Oregon Improvement Company purchased Henry H. Luse's properties and promptly constructed a huge wharf and new sawmill, seen in 1884 on the left side of this photograph. The U.S. lighthouse tender *Subrick* (a side-wheeler), two steamers, and a pile driver are docked nearby. (CCHMM 967-126G.)

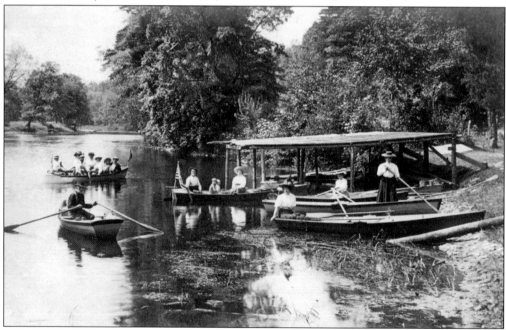

Life at the start of the 20th century was not just about backbreaking labor and working in the mines, forests, and shipyards. It was also about enjoying leisurely days on the rivers. Families often dressed up to go boating and have picnics on the waterways. This image dates to between 1905 and 1910. (CCHMM 975-340.)

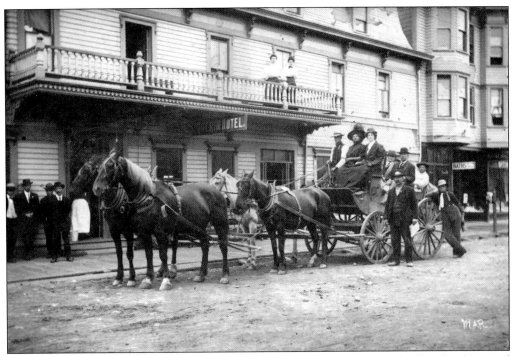

George Barklow was one of several local men who drove the mail stage, the Overland Limited Stagecoach, between Myrtle Point and Roseburg. Here Barklow has stopped in front of the Guerin Hotel. In 1914, the hotel became a main stopping point for the motor stage, which replaced the stagecoach as the preferred means of transportation. (CCHMM 988-P404.)

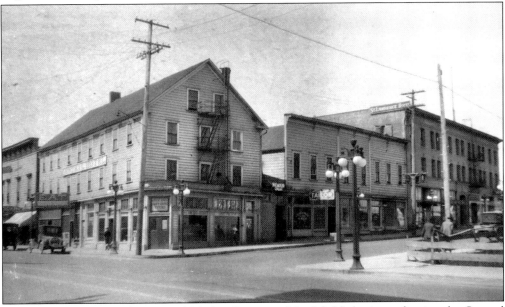

Located at the corner of Front and Market Streets in Marshfield's business district, the Central Hotel was built in 1870 alongside the Blanco Hotel, which opened two years earlier. The new hotels highlighted a shift in local attitudes toward enticing businessmen and paying travellers to the city rather than only catering to transients, such as miners and loggers. (CCHMM 992-8-1017.)

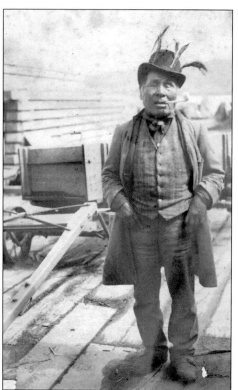

A popular sight at the Simpson sawmill, Chief Daloose Jackson was known as something of a dandy. Having made money by selling beaver hides to representatives from Hudson's Bay Company, he reportedly vowed to never again be without fine clothing. The Coos Indian was often seen sporting a "plug hat" and carrying a cane. Here he stands at the North Bend docks during the 1890s. (CCHMM 960-106.)

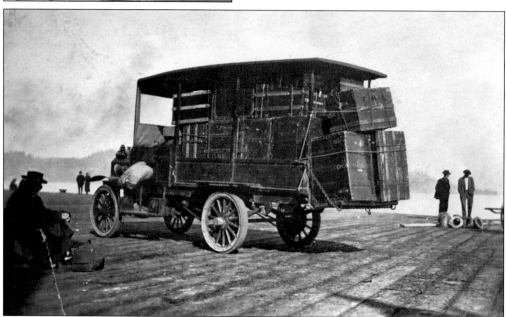

Before the arrival of motorized transportation, early settlers wishing to travel to or from Coos Bay had few options. Ships remained the most commonly used means of getting to distant ports well into the 20th century. As technology improved, passengers began to rely upon motor cars and trucks to aid their journeys. This photograph shows a loaded luggage truck on the docks at North Bend in about 1910. (CCHMM 992-8-0822.)

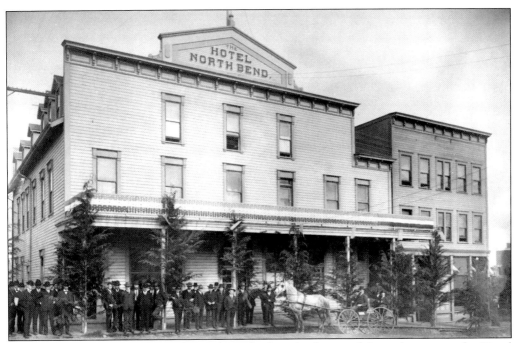

Begun in 1921, the North Bend Hotel was built to be fireproof. Later known as the Hotel Coos Bay, the state-of-the-art hotel was fitted with telephones, decorated with mosaic tiles and lavish furnishings, and had private bathrooms. It also housed the First National Bank of North Bend. In 2005, the aging structure was placed on the National Register of Historic Places. (CCHMM 996-42.6.)

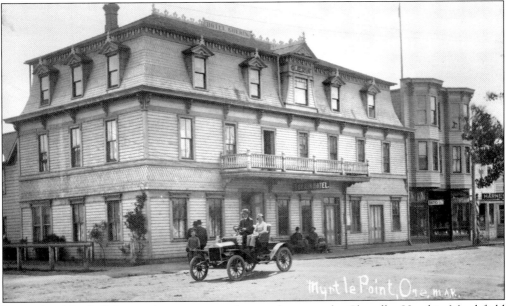

Located at Myrtle Point on the stage route that ran between the Chandler Hotel in Marshfield and Roseburg, the Guerin Hotel was built in 1897 by George H. Guerin. The hotel was a famous watering point and accommodated the likes of writer Jack London. In 1911, T. D. Guerin advertised his free autobus service, which met arriving trains. (CCHMM 967-132.)

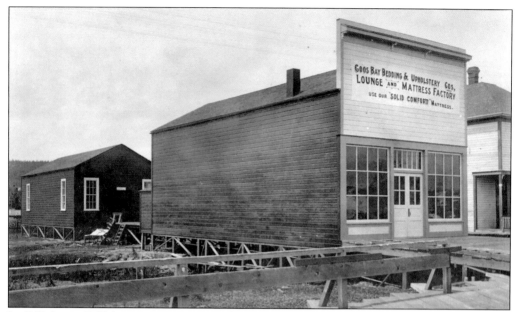

In 1853, James C. Tolman, a participant in the Coos Bay Commercial Company, identified the site that would become Marshfield as a perfect spot for a town. Naming the place after his hometown in Massachusetts, Tolman built a log cabin, a store, and a warehouse. The waterfront street soon acquired a variety of businesses, such as the Coos Bay Bedding and Upholstery Company's Lounge and Mattress Factory. (CCHMM 002-10.)

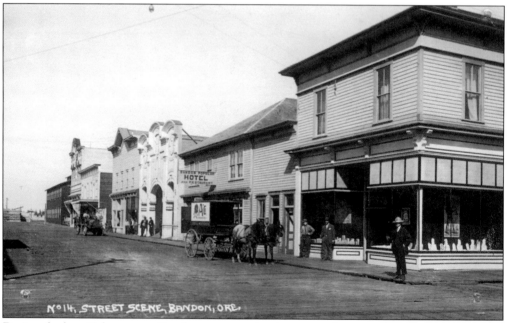

During the late 19th century, Bandon was poised to become a thriving commercial center, with its own sawmill, shipyard, and woollen mill, and an ideal location at the mouth of the Coquille River from where locally produced goods could be shipped. In 1913, the Port of Bandon was established and businesses lined the waterfront. A year later, a fire would destroy many of the buildings. (CCHMM 966-114.21.)

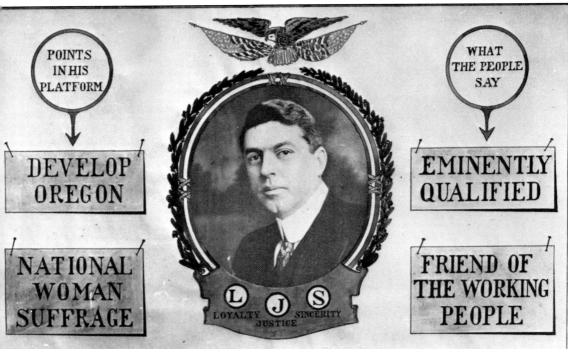

POINTS IN HIS PLATFORM

DEVELOP OREGON

NATIONAL WOMAN SUFFRAGE

WHAT THE PEOPLE SAY

EMINENTLY QUALIFIED

FRIEND OF THE WORKING PEOPLE

L J S
LOYALTY JUSTICE SINCERITY

# VOTE FOR L. J. SIMPSON FOR GOVERNOR

Born in 1877, Louis Jerome Simpson was one of North Bend's most influential founding fathers. The son of Asa Simpson, Louis began supervising the operations at the Simpson sawmill and shipyard in 1899, after his arrival in the bay area. His projects included the purchase of a townsite, Yarrow, which, when incorporated in 1903, was renamed North Bend. In 1903, Louis was elected the first mayor of North Bend and promptly began building a wharf, paving the streets, constructing new businesses, donating the land for the new hospital, and investing in other ventures. In 1918, the "eminently qualified" Simpson campaigned for the Republican nomination for governor of Oregon, but did not win the vote. In 1942, the State of Oregon purchased the final 637 acres of his property at Shore Acres for use as a public park. Louis moved to a small house in Barview, south of Empire, where he died in 1949, his legacy to North Bend assured. (CCHMM 992-8-0902.)

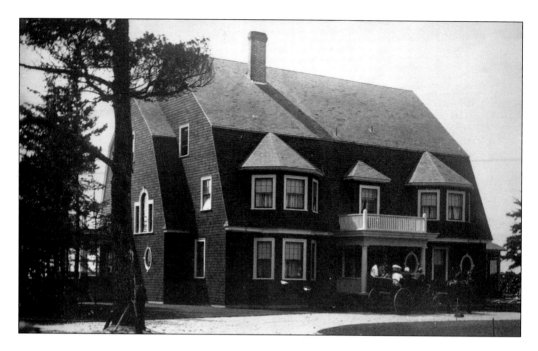

In 1906, Louis J. Simpson, then-mayor of North Bend, completed Shore Acres, his summer home at Cape Arago, which he shared with his family. Lumber came from the wreckage of the *Marconi*, which was built at the Simpson shipyard and launched in 1902. In 1921, the fine residence burned down, its furnishings all lost in the fire. Undaunted, Simpson rebuilt the place, but the second house was also lost, this time in the great Bandon fire of 1936. Afterward, he neglected the site. The charred ruins became unsafe, and Simpson sold off parcels to recoup his losses. Torn down after World War II, the state-owned site was transformed in a lush garden. (CCHMM 992-8-0350 and CCHMM 982-191-33.)

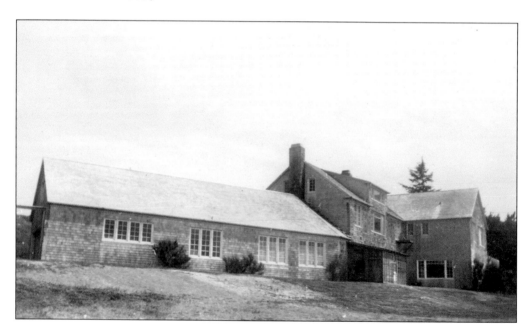

## *Two*

# MINING FOR GOLD AND COAL

In 1852, prospectors discovered gold in the black sands at Whiskey Run beach, a spot north of Bandon (shown) where the stream merges with the Pacific Ocean. There the waves washed away lighter sands to leave behind the heavier minerals, golden granules which could then be retrieved by panning. The first claim reputedly produced over $100,000 in gold. Storm activity soon washed away or covered up the gold with the heavy black sands, so miners abandoned this and similar sites along the so-called "gold coast" about a year later. (CCHMM 199.)

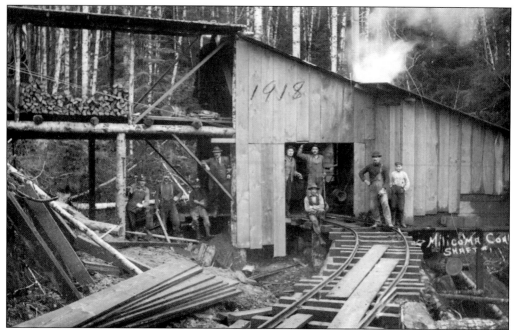

The discovery of coal veins throughout Coos County in 1853 led to the establishment of numerous mines. The entire coalfield stretched from Lampa Creek at the northern end of the county to the lower Coquille River. Sites included the Millicoma mine (seen here), the Gilbertson mine on Kentuck Slough, and the Black Diamond mine near the Haynes Inlet. James Flanagan, Patrick's son, managed the Hardy mine at Glasgow. (CCHMM 982-191.52.)

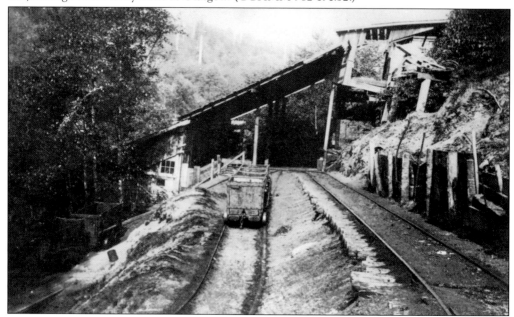

Established in 1854 by pioneer settlers Patrick Flanagan and Amos Emerson Rogers, the coal mine at Newport, south of Coos Bay, was one of the region's most successful mining ventures. During the 1880s, production soared, and between 40,000 and 75,000 tons of coal was pulled from the mine. Some 350 miners handled the load. (CCHMM 963-83c.)

In 1855, Northrup and Simonds opened the Eastport mine located near what is now Englewood and close to the Newport mine at Libby. Sold several times over to the Pershbakers and others, Eastport was closed in 1881. It reopened for a time in 1899 after the owners of the Newport mine finally bought the site. (CCHMM 981-149p.)

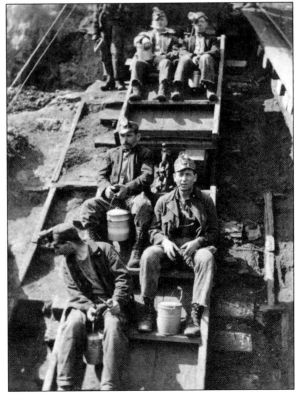

Considered a failure and also a success, the Beaver Hill mine opened in 1894. Located along Beaver Slough about 15 miles south of Marshfield, the mine operated for 30 years despite producing reputedly low-grade coal. In 1907, miners pushed for a wage increase and an eight-hour workday, which the Beaver Hill Coal Company resisted. About one-third of the men found jobs elsewhere. (CCHMM 981-244-15.)

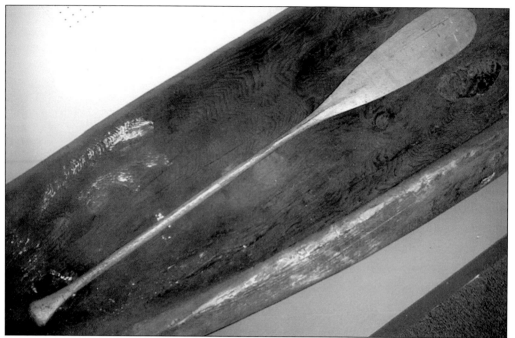

When coal mining began at Newport, a Coos Indian named Libby lived nearby. This oar, dated 1891 on one side and inscribed with "Libby" on the other, reputedly belonged to the woman. When residents established a post office at the site, Newport was renamed Libby in her honor, as another Newport already existed in Oregon. The oar is on display in the Coos County Historical and Maritime Museum. (CCHMM 972-9.)

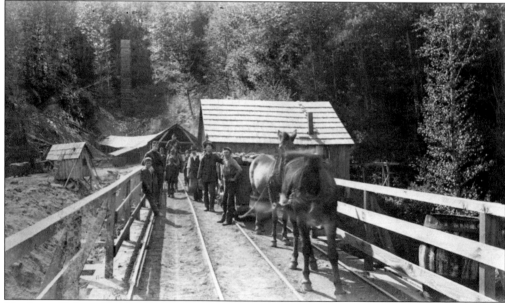

Used to pull the coal cars out of the mines, mule teams, such as these in Newport in 1898, were a common sight. Prior to the construction of the railway line linking Newport to Marshfield, the beasts lugged their burden to small bunkers, into which the coal would be loaded for delivery into another set of cars. The animals would then haul the load up Coalbank Slough. (CCHMM 992-8-0705.)

Besides the mine at Newport, Patrick Flanagan and his partner, Samuel Stillman Mann, owned the post office and store, which supplied the residents of the nearby settlement, later known as Libby. Several families lived in houses along the railroad tracks close to Coalbank Slough. The Flanagans had a home on a hill above the town. (CCHMM 992-8-0709.)

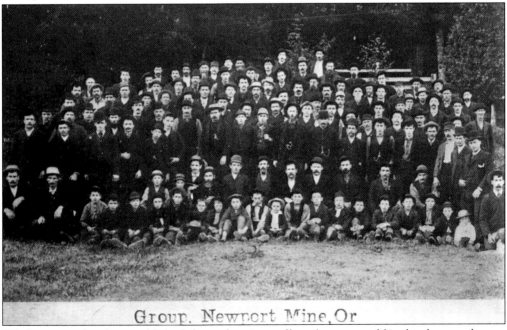

Group. Newport Mine, Or

While mining families established themselves in small settlements and lived in houses close to the mines, as at Beaver Hill and Libby, single miners were generally accommodated in bunkhouses and ate their meals at a community cookhouse. Besides helping out at home or attending school, children often also worked in the mines. (CCHMM 992-8-0710.)

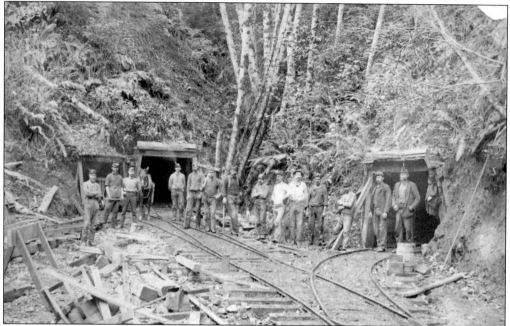

Moving coal from Newport to the ocean-going ships at Coos Bay was a complicated effort that involved both human and animal power. Miners loaded the coal onto cars, which horses or mules hauled along wooden tracks to the tidal waters of Coalbank Slough. From there, the coal was heaped onto flat-bottomed boats known as scows and was rafted to where the ships were moored. (CCHMM 975-143r.)

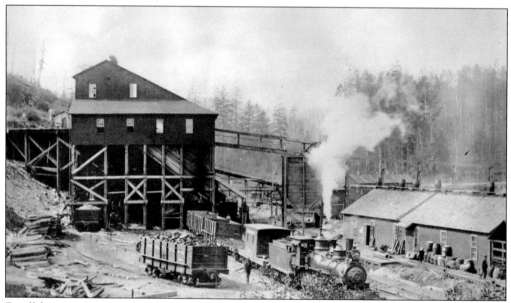

Small locomotives were used to haul 5-ton cars to bunkers closer to the coal ships where the coal was stockpiled until the ships were ready to load. During the 1870s, huge bunkers were built near the convergence of the Coalbank Slough, which carried coal from Libby and Beaver Hill (shown) and up Isthmus Slough to the southern side of the city, near what is now Bunker Hill. (CCHMM 963-83d.)

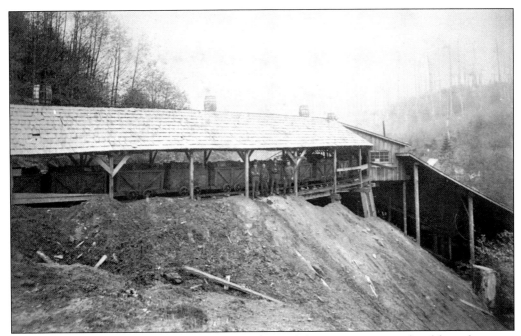

The introduction of coal bunkers in 1874 not only eased the transportation of coal from the mines to waiting ships at Isthmus Slough, they also made loading the ships much more efficient. Rather than taking several days to load a steamer, coal could be loaded in a matter of six hours using the bunkers. This photograph shows a coal bunker at Libby. (CCHMM 992-8-0707.)

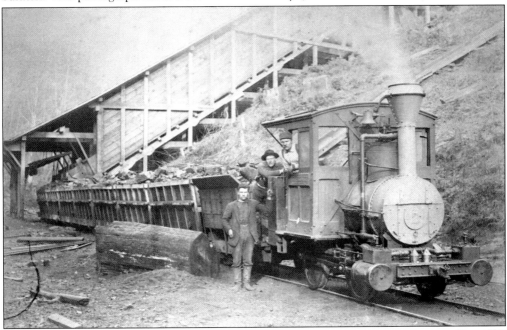

To keep the coal rolling to Coos Bay, Flanagan and Mann purchased "Locomotive No. 2" in 1878 at a cost of $4,000, an enormous sum in those days, and also lengthened the rail link between Newport and Marshfield. Operated by the Nyman brothers, the engine hauled loaded coal cars the two miles between the two sites. (CCHMM 992-8-0713.)

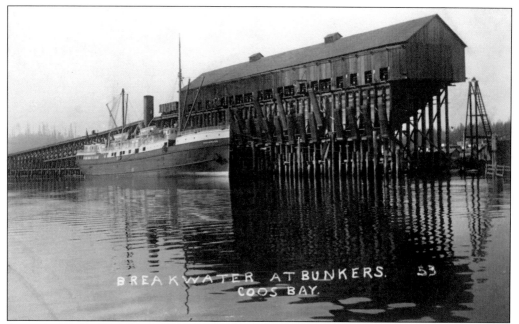

Steamships such as the *Breakwater*, seen here, and the *Empire*, could sail immediately underneath a bunker, which stored coal intended for distant shores. The bases of the bunkers opened to allow the coal to fall into the waiting ships. The *Breakwater* also transported passengers to San Francisco every six days. (CCHMM 985-28.5.)

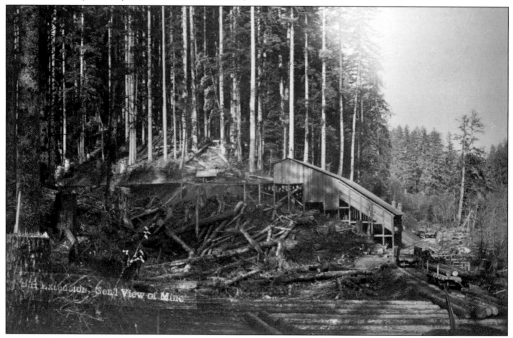

At one time, at least 74 mines operated in the county. Ships sailed up Coalbank Slough to the bunker at the Eastport mine, which was only about a mile from Libby. Trains used a trestle to dump their load of coal into the bunker at what is now known as Englewood. The Coalbank store was next to the trestle. (CCHMM 992-8-0696.)

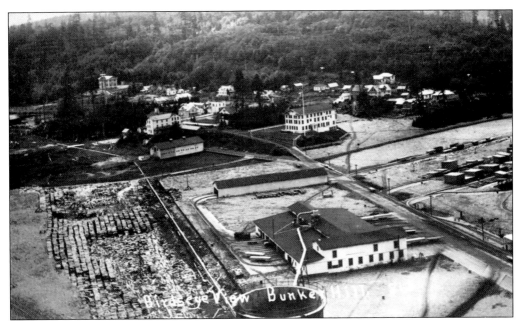

Located where Isthmus Slough converges with Coalbank Slough and Coos Bay, Bunker Hill acquired its name for the role it played in moving the county's coal onto ships and across the sea. Today the area south of what was once Marshfield is largely residential and commercial. When the mines were active, railcars hauled coal to the spot and transferred their loads into the bunkers. (CCHMM 992-8-0140.)

Coos County's close-knit mining communities had two things in common besides the mines: They each sported a baseball team and a brass band, which played at local celebrations. Libby was no exception, and men from the Newport mine took part in local festivities, playing a variety of horns and drums. In 1893, the Libby brass band entertained passengers on the first train trip to Myrtle Point. (CCHMM 992-8-0721.)

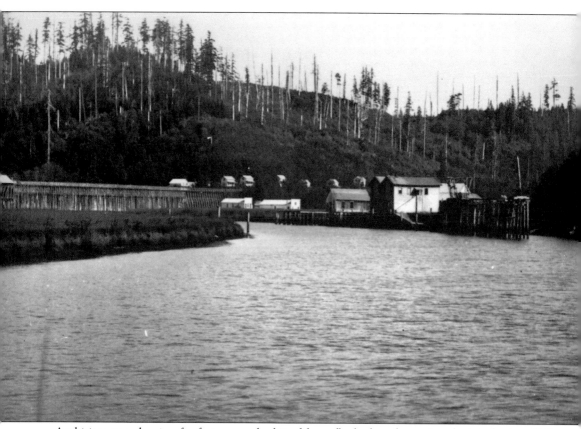

Ambitious men hoping for fortune and a bit of fame flocked to the region during the late 19th century, investing their money in forward-thinking projects they often named for themselves, but which almost as often failed to meet expectations. In 1874, the newly reformed Coos Bay Oregon Coal Company opened the Henryville mine on the eastern side of Isthmus Slough, near the mouth of Davis Slough. Named for a Dr. Henry, the main backer of the project, Henryville had its mine and also a small waterside town, with a large, costly wharf, warehouse and store, a boarding house and 14 individual homes, a smithy, and coal bunkers. What the site lacked was a vein of high-grade, easily mined coal. In 1876, after pouring hundreds of thousands of dollars into the effort, Dr. Henry and his colleagues abandoned their investment. The mine reopened briefly in 1885, but an explosion the following year forced owners to close it for good. (CCHMM 992-8-0695.)

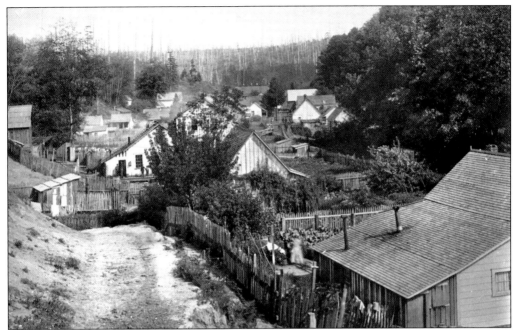

By 1893, the town of Libby had developed into a notable settlement and had a school that supported the families whose men worked in the Newport mine. Besides miners, the site employed a doctor (Charles W. Tower), bookkeepers, underground bosses, a clerk, and a meat cutter. Some miners worked their own farms during part of the year. (CCHMM 992-8-0700.)

Located amid a series of coal beds that crossed the Coquille River, Riverton was once a hub of activity. Several mines sprang up around the town, including the Timon vein, named for J. T. Timon, who maintained a line of steamers, each of which could haul an average of 200 tons of coal. Early Riverton also had a schoolhouse, post office, church, markets, a sawmill, and hotels. (CCHMM 977-91.)

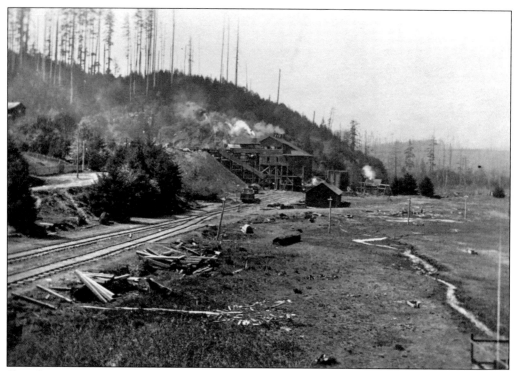

Shut down in 1923, not only due to the nation's increasing reliance on fuel oil over coal, but also to years of mining disasters, accidents, explosions, and fatalities, the Beaver Hill mine has long since vanished from the landscape. So has the accompanying town, which once bustled with activity and had a population of between 100 and 200 people. The settlement had its own four-room schoolhouse, which was also used for a variety of social gatherings and church services. In addition to white miners and their families, the community was home to African American, Japanese, and Mexican residents. (CCHMM 981-244-18 and CCHMM 981-244-12.)

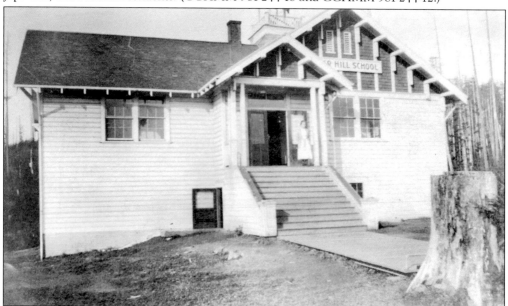

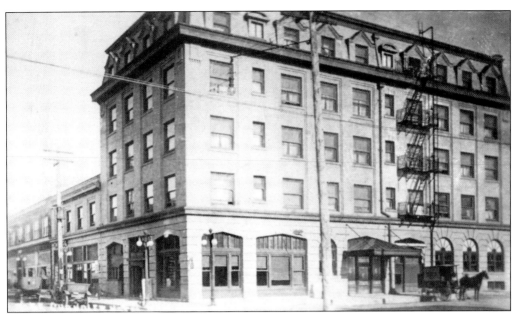

Located on Central Avenue in Marshfield, the Chandler Hotel was named for William S. Chandler, superintendent of Beaver Hill mine, under whose management the mine became one of the most successful in Coos County. Designed by the firm of Bennes, Hendricks and Tobey, the hotel marked the dawn of a new era in the bay area. The lavish hotel opened in 1909 and was one of several hotels constructed in Marshfield and North Bend to relieve shortage of accommodations. The five-story structure had four floors of guest rooms, a ground floor lobby, reception room, dining room, barbershop, and other ornately decorated facilities. The basement contained a modern steam plant, a trunk room, and a wine cellar. This pitcher, inscribed with the Chandler Hotel logo, is typical of the items guests enjoyed. (CCHMM 962-44E and CCHMM 986-23a.)

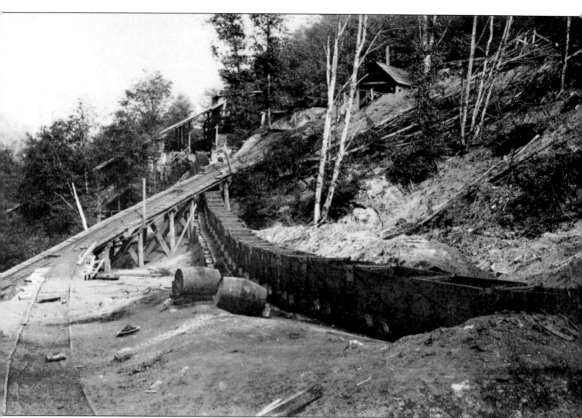

In 1883, Capt. George Holt, who operated the steamer *Arcata*, completed his purchase of the Newport mine from Flanagan and Mann and renamed the company the Newport Coal Company. For a time, Patrick Flanagan stayed on as the mine's superintendent. Holt spared little expense to make the mine into what he thought would be a vast success, hiring John Kruse from Asa Simpson's shipyard to build an enormous bunker and building the schooner *Arago* in San Francisco, which he used to haul coal from Coos Bay. Holt's debts were so high that, in 1886, he sold the mine to the Coos Bay Coal and Navigation Company, which sold it the following year to Goodall and Perkins. In 1888, Flanagan resigned, established the Flanagan and Bennett Bank in North Bend, and moved to Empire, where he maintained a residence until his death in 1896 during a visit with family members in San Francisco. (CCHMM 992-8-0702.)

## *Three*

# Logging and the Mills

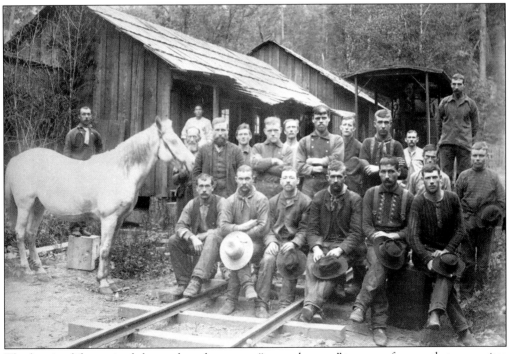

The logging life required the workers, known as "tramp loggers," to move frequently to new sites as the forests became depleted of trees and supplies dwindled. Logging camps were uncomfortable at best but temporarily filled the men's basic needs for shelter, food, and warmth. Good cooking was a precious commodity and cookhouses with reputations for the quality of their food attracted workers to the camps. These men at R. E. Scranton's logging camp were fed by a Chinese cook, who stands behind a group of loggers in the cookhouse doorway. (CCHMM 992-8-0392.)

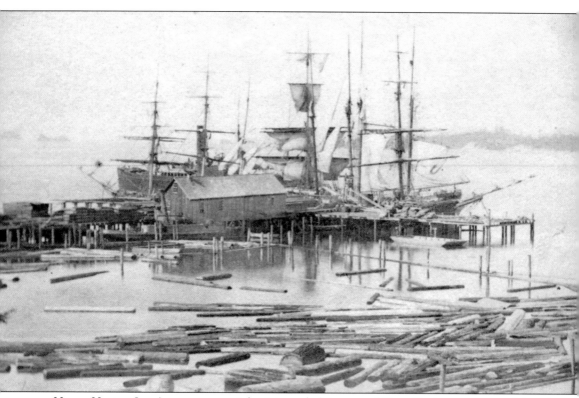

Henry Heaton Luse's entrepreneurial spirit made him one of Coos Bay's most successful early settlers. Arriving in 1852, it took Luse less than four years to construct a sawmill at Empire City, which initially cut 10,000 board feet of timber each day. In 1867, Luse opened a shipyard alongside his sawmill. The following year, he launched the *Alpha*, a 65-foot long steam-propeller boat. He also opened a company store, visible in this image alongside the *Alpha*, which sold hosiery, gloves, veils, oil cloths, boots, carpets, and hardware, and plenty of other items. Thirty years later, when Luse sold the mill to the Southern Oregon Improvement Company, its output had doubled. In 1873, E. B. Dean and Company began operating a steam-powered plant in Marshfield. Within a year, the company had become stiff competition for both Luse and Asa Simpson. One of the original owners of E. B. Dean and Company was Charles H. Merchant. (CCHMM 988-P88.)

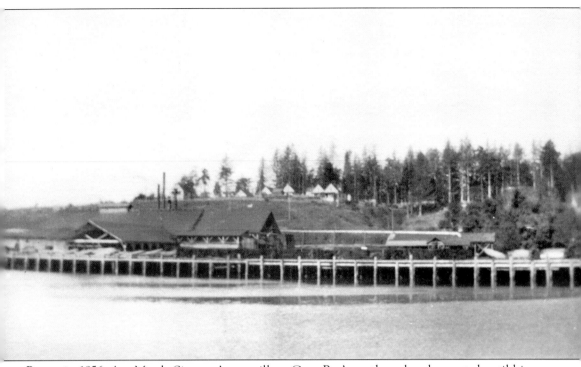

Begun in 1856, Asa Meade Simpson's sawmill on Coos Bay's northern bend operated until his death in 1915. Having come from California to Oregon, Simpson reputedly brought his new mill from Sutter's Mill, which flourished during the Gold Rush. Alongside the mill, Simpson soon added Oregon's first shipyard and several other facilities, including a store, offices, a warehouse, two large bunkhouses ("bunkalations") for his single workers, and homes for families. In 1902, his son, Louis J. Simpson, purchased the townsite known as Yarrow, which bordered the mill site, and Asa's mill became known as Old Town North Bend. It was leased out in 1916 to the Bay Park Lumber Company and later bought by the Coos Bay Logging Company. Louis Simpson served as its president in 1926. The Old Town mill operated until 1950, when it was demolished by Weyerhaeuser. (CCHMM 981-313.22.)

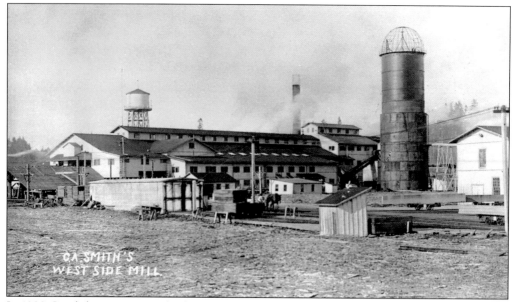

In 1908, Swedish immigrant, Charles Axel Smith, established the C. A. Smith Logging Company after purchasing thousands of acres of timberland and milling facilities from the E. B. Dean Lumber Company. From 1908 to 1951, the company, and its successors, was the region's largest employer. Known as the "Big Mill," Smith's westside mill faced Isthmus Slough. Towering over the other structures, the impressive slash burner dominated the site. (CCHMM 992-8-0138.)

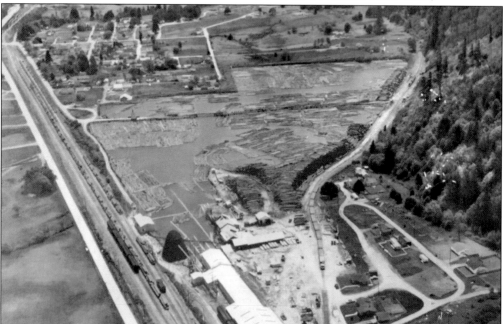

Albert Powers was C. A. Smith's right-hand man as well as the vice president and general manager of the Smith-Powers Logging Company. Powers not only established a number of logging camps but also the company town, which was named for him. The townsite was located at the distant end of a 19-mile stretch of railroad constructed by Southern Pacific to link the forests to its terminus at Myrtle Point. (CCHMM 971-139.)

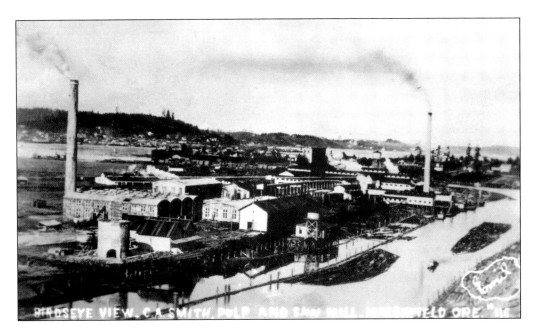

C. A. Smith initially manned his huge milling operation with workers from Sweden and Finland with whom he had worked in Minnesota. Many were skilled smiths, machinists, sawyers, and millwrights. His sawmill on the east side of Isthmus Slough (above) was just one of Smith's successful ventures. Smith also operated a pulp mill (below), a shingle plant, several logging railroads, logging camps, docking facilities for his ocean-going ships, and booming and rafting facilities. He also shared control of the Smith-Powers Logging Company with Albert Powers. The C. A. Smith Company and its later owners, including Georgia-Pacific, dominated the local lumber industry until the 1950s, when Weyerhaeuser began operating its new mill complex. (CCHMM 963-14g and CCHMM 963-14h.)

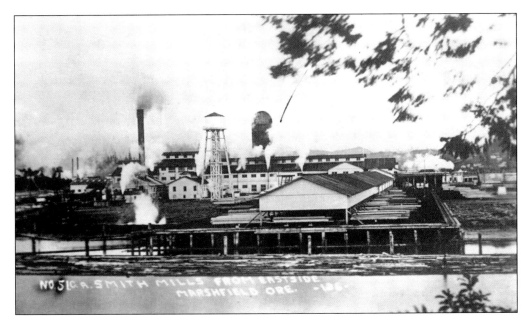

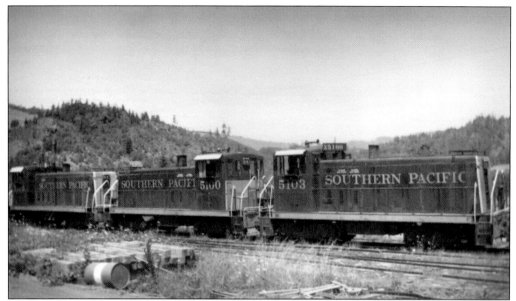

The railroad from Powers extended in several directions to reach logging camps deep in the forest. So, special engines were built that could negotiate the steep hillsides and still haul the lumber back to Powers. The Smith-Powers Company reportedly had more trestles than its competitors. This image shows engine No. 5103, owned by Southern Pacific. (CCHMM 977-101.172.)

The company town at Powers was built on the site of the David Wagner ranch, which the Smith-Powers Logging Company purchased in 1912. Albert Powers then had the site platted so that individual plots could be offered to employees. A member of the North Carolina colony, David Wagner established a gristmill on his 166-acre property. The Wagner family's house is open to the public. (Author's collection.)

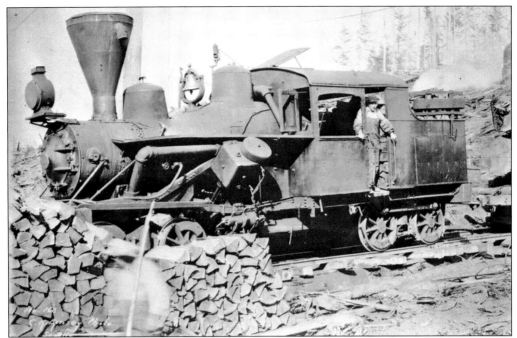

Three types of locomotive proved essential to logging operations: Shay, Climax, and Heisler engines. Here lumber from the Vaughan camp at Greenacres is hauled with a Heisler engine. Invented in 1891, the Heisler was the quickest of the three gear-driven steam locomotives, which had the necessary traction to move the logs around sharp curves and up steep hillsides. (CCHMM 992-8-0490.)

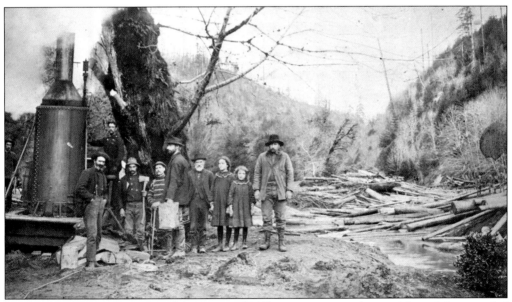

At Allegany, near the junction of the Coos and Millicoma rivers, residents celebrated the arrival of their first steam donkey with engineer William Robinson (bareheaded). From left to right are George Stemmerman Sr., Fred Noah Sr., an unidentified man with an ax, Dan Mattson, Frank Vincamp, Jake A. Sawyers, Hilda Sawyers, Maggie Sawyers, and Jordan Schapper. (CCHMM 992-8-0373.)

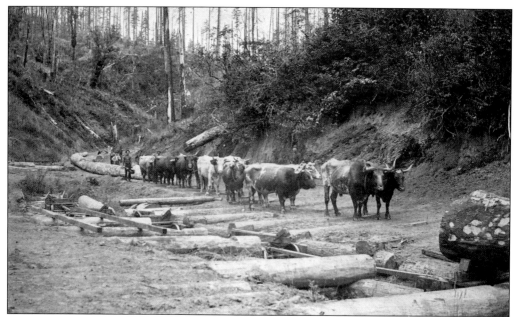

Teams of oxen used skid roads to haul logs from forests. The roads consisted of a series of "skids," or large poles, which were greased with lard or a similar material to smoothen out the movement of the logs as the ox teams, coaxed by their "bull puncher," dragged them to the waterfront, where they were dumped into Isthmus Slough and floated or towed downstream. (CCHMM 992-8-0397.)

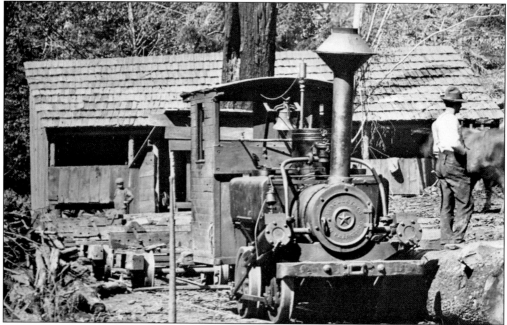

Introduced just before the start of the 20th century, steam-powered locomotive engines, such as this Hinkley logging engine, were a great benefit to the lumber industry, making it easier to transport large numbers of logs from inland forests to the coast, where they could be milled or shipped from Coos Bay. (CCHMM 992-8-0183.)

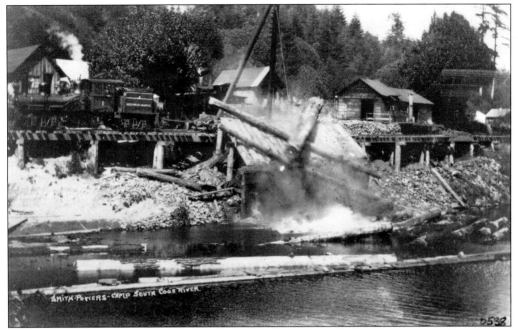

Even though trains were available as early as 1914, logging companies whose sites were off the beaten track still had to dump their harvest into rivers and estuaries, which they relied upon to move their timber the last leg of the journey to Coos Bay. Here the Smith-Powers logging train dumps its logs into the water at the head of Isthmus Slough. (CCHMM 995-D118.)

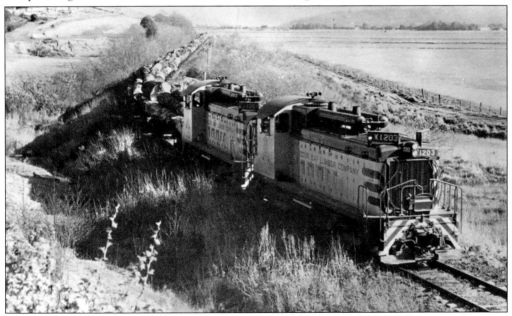

The completion of railroad links in 1893 eased the difficulties of moving heavy timber from the forests to the mills and to waiting ships not only between Coos Bay and Myrtle Point, but also from the outlying areas. Coos Bay Lumber was just one logging company that made ample use of trains to haul logs. Here engines No. 1201 and 1203 tow a day's load for the company. (CCHMM 977-101.34.)

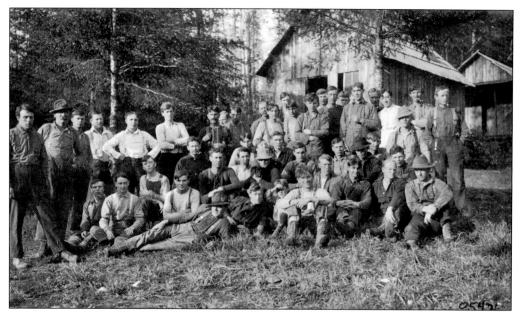

At Lampa, the Conlogue brothers operated one of the many logging camps that dotted the northern part of Coos County. Besides housing loggers, families, and other essential workers, these camps were used to store equipment and as bases from which the men headed into the forests. When the woods were depleted, the camps shut down and moved to the next logging site. (CCHMM 995-D11.)

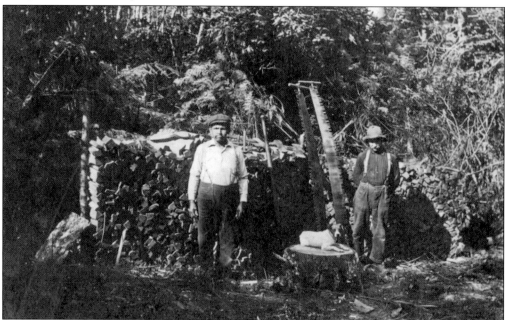

Well into to the 1930s, hand fallers such as Indian Bob (left) and Charlie Nicholas used two-handed crosscut saws (also known as "hand briars") to bring down the giant trees. Even though by then technological advances had produced innovations such as the chain saw, many loggers continued using the more familiar, labor-intensive methods to complete their day's work. (CCHMM 958-55b.)

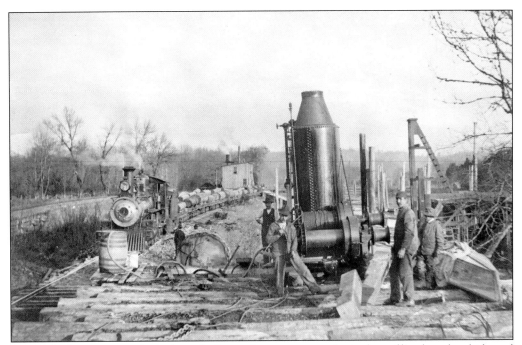

Steam donkeys consisted of a huge boiler and steam-powered winches affixed to the skids and provided the power to lift logs suspended on cables into wagons and railroad cars. The person operating the machine was the "donkey puncher," the man working the winches was the "skinner," and the "swamper" kept the boiler lit. The lowly machine could not compete with a horse when it came to power output. (CCHMM 987-10.7.)

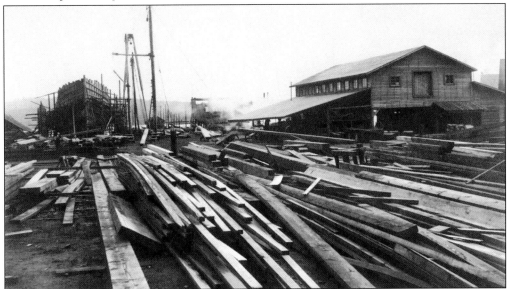

In 1903, Asa Simpson purchased and refurbished the Porter Mill, which was built in the 1880s. Part spar yard and part mill, workers produced rough-hewn lumber, which was used for masts, booms, and yards. The last vessel built by Simpson interests at the Porter yard was the *Alpha*, a three-masted schooner. In 1926, a fire destroyed the Porter Mill, which the Stout Lumber Company then owned. (CCHMM 981-284.81a.)

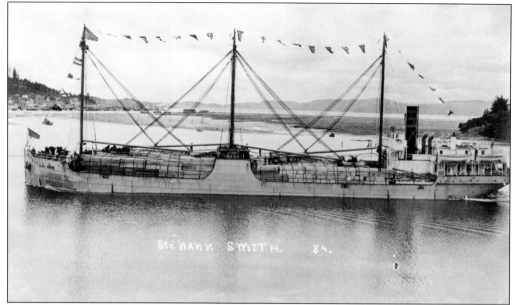

In addition to being a success in the lumber industry, C. A. Smith was a proud family man. When he purchased ocean-going ships capable of hauling millions of board feet of lumber, he named two of the vessels after his daughters, Adeline and Nann. Here the steamer *Nann Smith*, laden with lumber, sails out of Coos Bay. (CCHMM 985-25.30.)

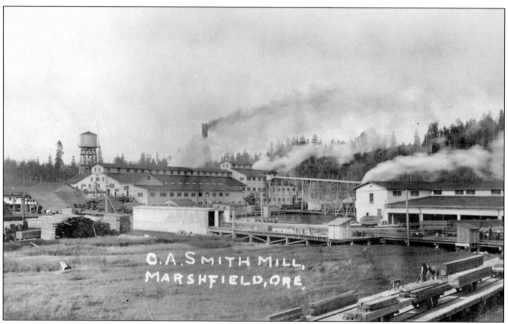

As lumber prices fluctuated and fell, so did C. A. Smith's fortunes. In 1916, his company was forced to reorganize and was renamed the Coos Bay Lumber Company. Smith stayed on in an advisory capacity. The Big Mill continued to operate, but its erratic financial status reflected the uncertainty of the times. (CCHMM 980-52a.)

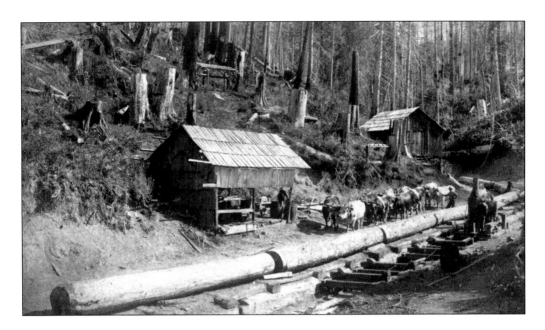

Bull and ox teams provided the bulk of the power during the early years, but their efforts were reliable only when the weather cooperated. When it rained, the pathways were difficult, if not impossible, for both beast and human to navigate. The introduction of the steam donkey in the 1880s enabled work to continue year-round and made the process of moving the logs to the riverside much easier. From there, the logs could be rafted downstream or loaded onto railroad cars. Coos County's loggers were especially slow in making the shift from using steam donkeys to relying upon logging trains to handle the load. The mechanical donkeys were used well into the 1930s. (CCHMM 992-8-0380 and CCHMM 981-191.)

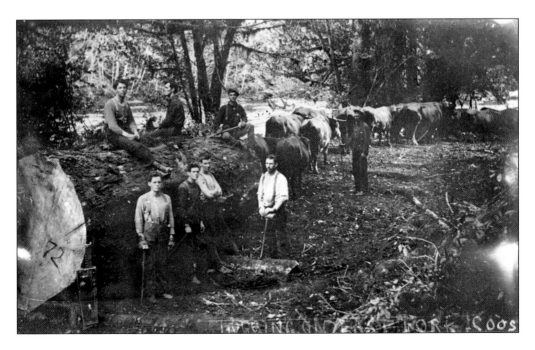

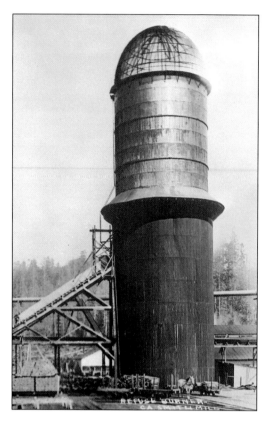

The slash burner at Smith's Big Mill destroyed scrap pieces of lumber, including wood chips, which were considered waste products. With the introduction plywood and pulp mills, the unwanted residue found new uses and the burners gradually became obsolete. In time, they were outlawed due to the air pollution created from the heavy smoke they released. Some burners had an unusual wigwam shape. (CCHMM 992-8-0157.)

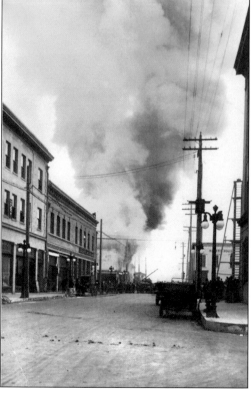

The social as well as commercial center of the bay area, Front Street in Marshfield was a well-known hangout for transient loggers—single men without families who moved from camp to camp. Saloons, hotels, banks, restaurants, and brothels were within walking distance of each other. In 1922, the waterfront businesses were devastated by fire. (CCHMM 980-8a.)

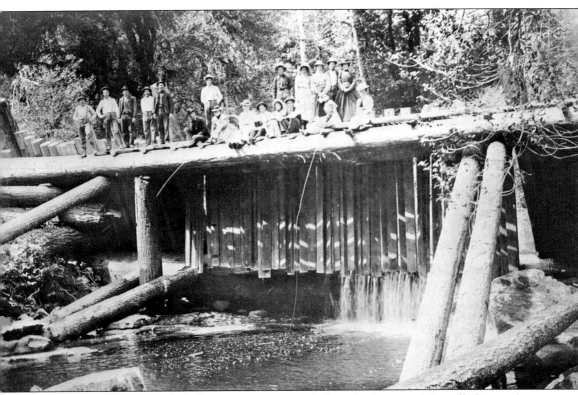

First used in 1894, several splash dams were constructed along the Coos and Coquille Rivers. At least 25 dams operated on the Coquille River, and probably as many on the Coos. A dam at Jordan Schapper's logging camp on the North Fork of the Coos River consisted of cleverly placed timber beams that restrained river water and logs until the exact moment conditions were right for their release. The timbers at the front of the dam kept the structure in place until the men pried them up. The action caused a sudden rush of water, the splash, which thrust the logs trapped behind the dam downstream. Sometimes the onslaught of logs would cause logjams and the flooding of adjacent farmland. Salmon spawning beds were destroyed as well, and debris often blocked the streams. Widespread splash damming continued until 1946. (CCHMM 992-8-0375.)

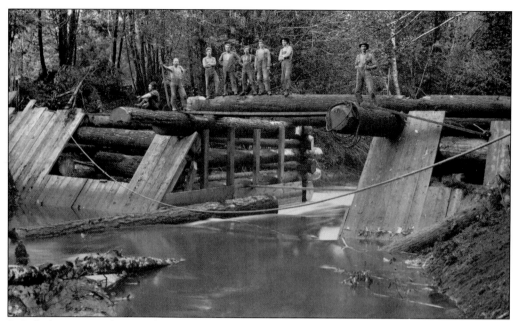

Splash dams created an artificial accumulation of logs during the summer, so that logging could continue without interruption. During winter months, when bad weather interfered with logging, the dams were opened. The rushing waters swiftly moved the logs downstream for stowage or transportation to another site. The Aasen Brothers' splash dam was used on the Coquille River in 1912. The last dams were removed during the 1950s. (CCHMM 992-8-0367.)

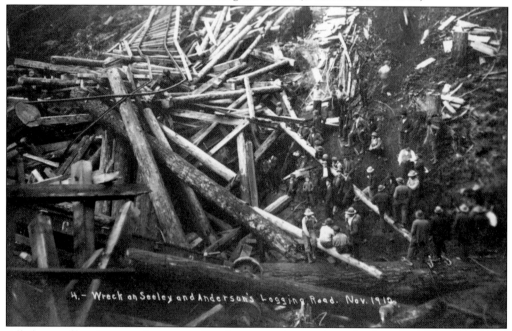

All phases of logging were dangerous. Deaths occurred not only in the forests, but also during the transportation of the logs. In 1912, a logging train heavily burdened with timber wrecked while crossing Seeley and Anderson's trestle, which spanned Bill's Creek, near Bandon. Six men died. Only one managed to survive. (CCHMM 992-8-0534.)

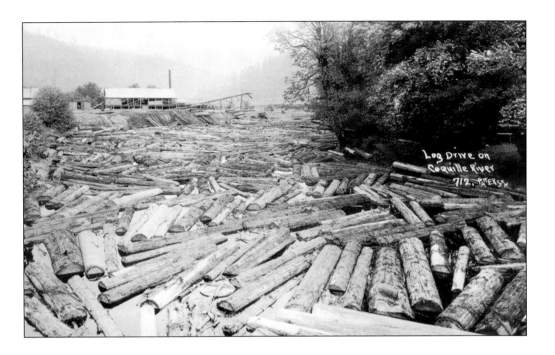

Ensuring logs and railroad ties made their way downstream was no simple task, and jams often happened no matter how hard the crews worked to avoid them. Unjamming the logs was dangerous at best, as the workers, nicknamed "river rats," had to scramble onto the rolling beams and free them using "peavies," long poles fitted with steel spikes and a hook, or explosives. When men fell into the water, they often drowned or were crushed by the massive logs. The Coos Bay Logging Company ran the last logging drive on the North Fork of the Coquille River in 1941. During the drive, two men were killed. (CCHMM 995-17.8f and CCHMM 959-317K.)

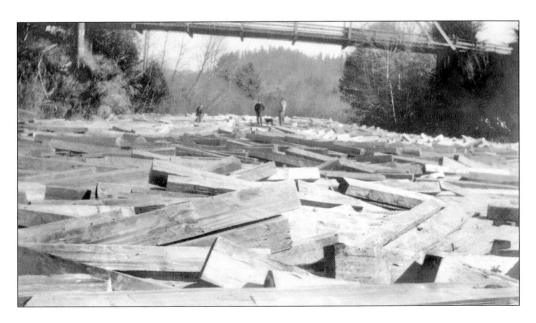

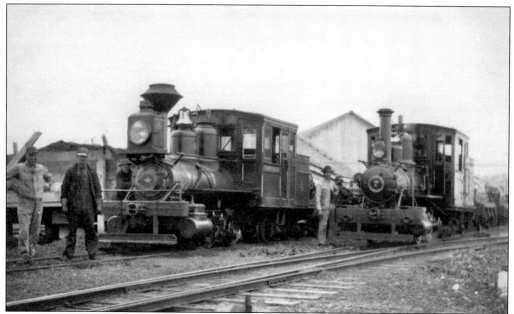

During the 1920s, the Coos Bay Lumber Company employed some 1,500 workers not just to harvest the timber, but also to ensure the logs reached Coos Bay. They moved them to the waterways that led to the mills with locomotives such as those seen here, Nos. 4 and 7. Booming and rafting crews then sorted the logs by type and floated them down the slough on large rafts. (CCHMM 977-101.139.)

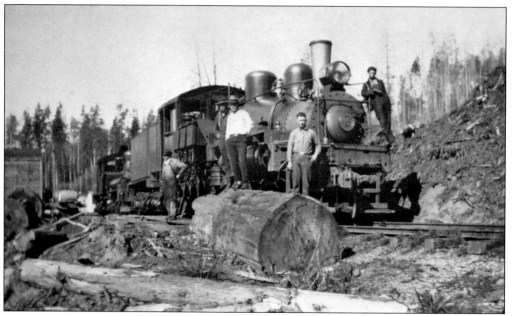

The Coos Bay Lumber Company had its share of difficulties. Pressure to maximize output during World War I led to "highballing," and employee turnover was extremely high. The onset of the Great Depression forced the closure of logging camps and mills, and the Coos Bay Lumber Company had to reorganize once again. This image shows logging camp No. 8 at Yellow Creek near Powers. (CCHMM 992-8-0304.)

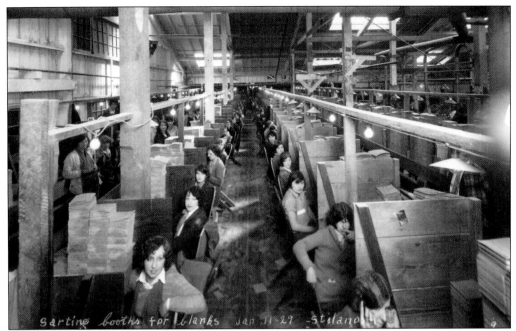

Sorting booths for blanks Jan 11-29 -Stilano

During the Great Depression and World War II, families began to rely upon women workers to bring home wages. Some women worked in the mills or as whistle punkers during logging operations. In 1928, the Evans Products Company built a plant in Marshfield and employed women to make battery separators from Port Orford cedar and other local timber. Nicknamed "Lumber Jinnies" (as opposed to "Lumber Jacks"), the women worked in individual booths where they sorted out blanks (above) or operated grooving machines in the separator department. The business prospered until after the end of World War II, when plastic was introduced as a viable alternative to wood, and much of the workforce was laid off. (CCHMM 987-5.48 and CCHMM 987-5.53.)

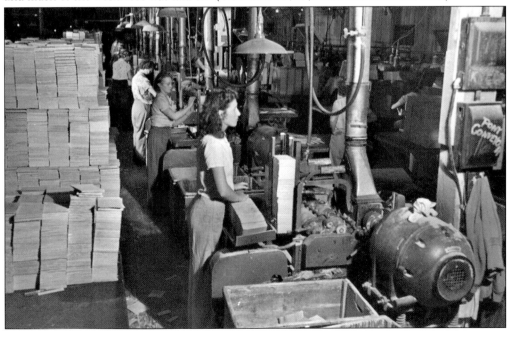

World War I and II were both a strain and a boost for the local economy. The government's demand for new ships, lumber for new buildings and railroad construction, and timber products, such as pulp for making paper, increased dramatically and forced the mills and shipyards to produce at more intensive pace. During World War II, the lumber industry was hit particularly hard by manpower shortages as loggers and mill workers headed for better paying jobs at the shipyards or headed into the military. The situation was so bad that new regulations were enacted to encourage the men to stay put. Not only were the local draft boards expected to exercise caution when classifying the lumbermen who worked in the forests, but the government's War Manpower Commission implemented a "freeze" on men doing "essential war work," which required them to stay in their current jobs unless they had special permission to do so. The shortage remained acute throughout the war. (CCHMM 980-250.27.)

*Four*

# SHIPPING AND SHIPBUILDING

Claiming the largest natural harbor with the deepest draft between San Francisco and Puget Sound, Coos Bay was the ideal location for a booming shipping industry. In 1909, the Port of Coos Bay was founded. Commissioners A. O. Rogers, Jim Montgomery, Henry Sengstacken, and R. H. Corey pose alongside a car in 1920. Besides serving as a commissioner, Sengstacken, an emigrant from Germany, was a local businessman and also served as mayor of Marshfield in 1903. Sengstacken's house, which was built in 1904, is listed on the National Register of Historic Places. (CCHMM 977-35.)

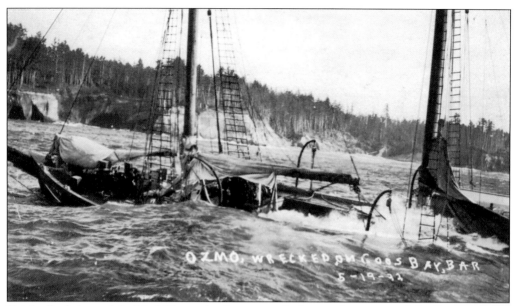

Originally christened the *Hugh Hogan*, the three-masted schooner, later renamed the *Ozmo*, wrecked on the Simpson Reef near Cape Arago in 1922. The treacherous conditions on the Coos Bay bar and other landmasses have caused scores of shipwrecks since 1852, when the *Captain Lincoln*, a steamer, beached itself near the entrance to the bay. Its survivors, known as "the Castaways," helped found the first settlement at Coos Bay. (CCHMM 961-33.8.0.)

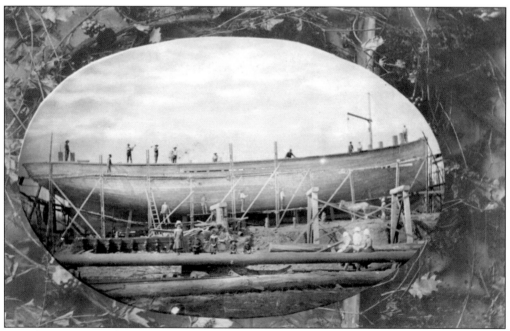

From brigantines and barkentines to schooners and steamers, Coos County's small number of shipyards put out scores of ships, including several firsts on the Pacific Coast: the first four-masted schooner; the first four-masted "barkentine"; and the first five-masted schooner, the *Louis*, which was named for Asa Simpson's son. (CCHMM 987-17.3.)

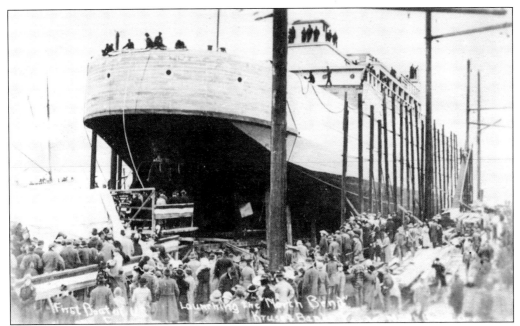

The Kruse and Banks Shipbuilding Company, the largest shipyard at Coos Bay, began building ships in 1905. The company produced schooners, steamers, ferries, tugboats, barges, and stern-wheelers. Tasked to build 10 wooden ships during World War I, the shipyard employed some 500 workers to meet the government's needs. In 1918, they launched a four-masted schooner, the *North Bend*, as part of the Emergency Fleet Corporation. (CCHMM 981-284c.)

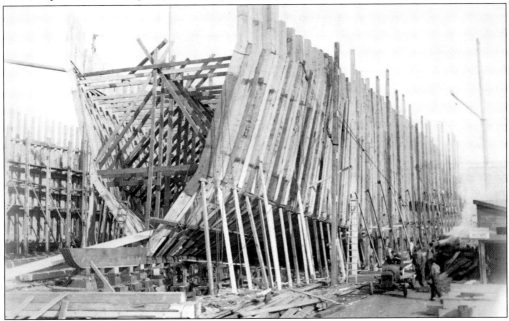

The construction of a new ship at the Kruse and Banks shipyard involved laying the keel and then adding a rib-like frame supported with wooden beams and shaped to form the hull. Some of the beams were manually hoisted into place using wire rope and wooden cranes. The image shown here was common during the prewar years in Marshfield and North Bend. (CCHMM 981-284.78.)

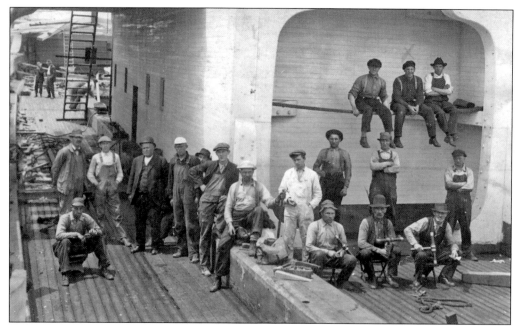

Steam schooners were routinely constructed at the Coos County shipyards, the first of which was part of Asa Simpson's North Bend sawmill. These projects required an enormous output of labor and ready supplies of lumber, which came from the surrounding forests. Shipyards employed scores of workers, many of whom were highly skilled, such as shipwrights, platers, engineers, boilermakers, and woodworkers, including carpenters, joiners, and cabinet makers. (CCHMM 995-16.7g.)

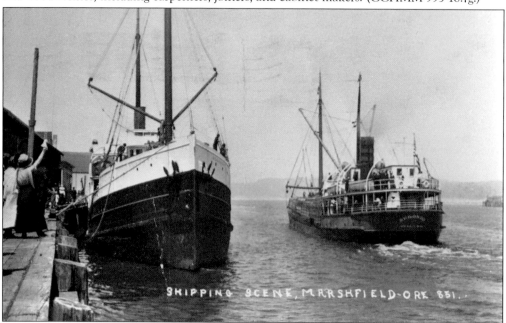

In addition to the *Nann Smith* and the *Adeline Smith*, named for his daughters, lumberman C. A. Smith also owned the *Redondo*, a steamer, which hauled lumber from the Coos Bay area and returned laden with supplies and equipment. All three ships also carried passengers, primarily company personnel, back and forth to San Francisco. (CCHMM 992-8-0131.)

In order to make the most out of the transportation potential provided by the Coquille River, Congress approved funding for the construction of jetties and a lighthouse at Bandon. The South Jetty was completed in 1887, but it took several more years to finish the North Jetty and the Coquille River lighthouse. This photograph shows women enjoying the sandy beach underneath the jetty walkway, still under construction. (CCHMM 987-10.5.)

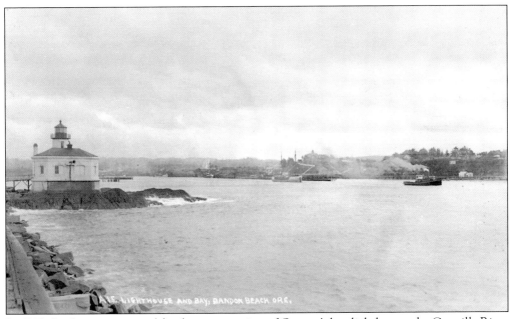

In 1895, funds were approved for the construction of Oregon's last lighthouse, the Coquille River Light, which opened officially in 1896 on the northern side of the Bandon bar. The lighthouse had a fourth-order Fresnel lens, the light from which could be seen from 12 miles at sea, and a third-class Davolit Trumpet fog horn, which blasted every five seconds. It was automated in 1939. (CCHMM 995-17.8u.)

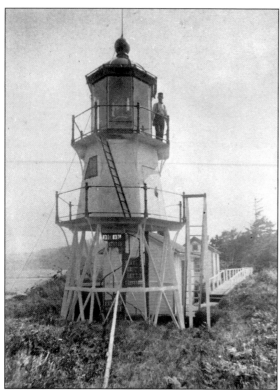

Built in 1866, the first lighthouse at Cape Arago was a simple structure. The second lighthouse to be erected on the Oregon coast, its octagonal tower housed a fourth-order Fresnel lens. It illuminated the mouth of the bay and the coastline. Two other lighthouses were built, one in 1908, which later became the keeper's quarters, and the surviving lighthouse, in 1934, which is on the National Register of Historic Places. (CCHMM 992-8-0620.)

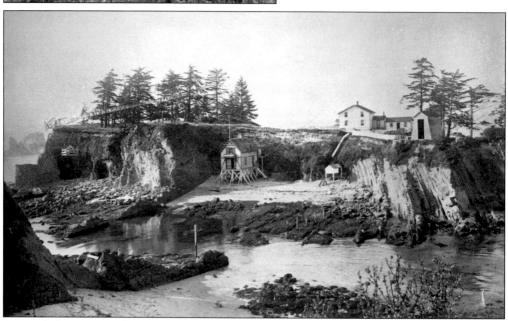

Situated about two miles southwest of Cape Arago Light, Oregon's first lifesaving station was built on Gregory Point in 1878. Initially reached by rowboats and via a low-lying bridge, the Coos Bay Life-Saving Station was manned by a single keeper, who had to gather volunteer crewmen for rescue efforts. In 1891, the station moved to the North Spit, and in 1916, moved again, this time to Charleston. (CCHMM 992-8-0610.)

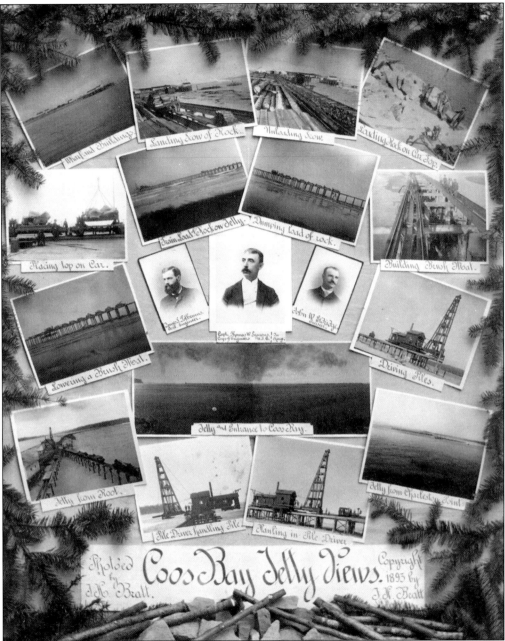

Constructing the North Jetty was a complex, labor-intensive venture that required innovative thinking and a carefully thought-out plan, as shown in a montage of photographs taken in 1893, which illustrates the construction process in action, from loading the railcars and hauling the massive rocks to the site to installing the pile driver, driving the piles, and building the "brush moats." James Suydam Polhemus, who designed the project, is identified as the assistant engineer. By 1901, some 637,000 tons of sandstone from quarries along the Coos River had been dumped along the North Jetty. The structure maintained the channel's depth at between 18 and 22 feet of water at low tide—but only for a few years. In 1921, a proposal would be submitted to revamp the jetty and construct a second jetty on the southern side of the Coos Bay bar. (CCHMM 959-280A1.)

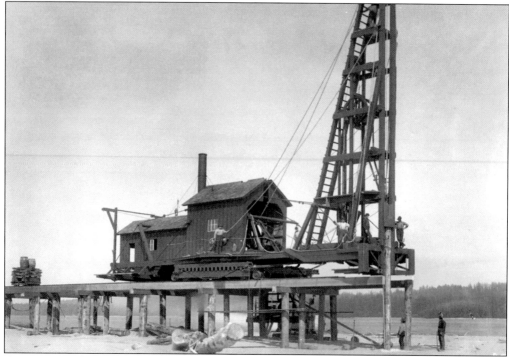

Constructing the North Jetty involved erecting a tramway to support loaded railroad cars as they moved out over the bay at the end of the North Spit. A revolving pile driver that had worked on the Columbia River Jetty was shipped to Coos Bay. Working from July to October 1891, the pile driver embedded enough pilings so that the tramway extended some 1,800 feet into the Pacific Ocean. (CCHMM 959-280A3.)

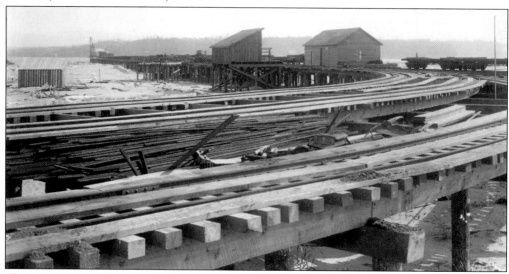

The innovative method by which James Suydam Polhemus constructed the North Jetty consisted of erecting an elevated railway trestle, or tramway, which projected seaward from a wharf at the end of the Coos Bay bar well above the water. From there, rock and timber pilings were carted to each day's site and dropped onto brush "mattresses" or "moats" situated beneath the tramway to help prevent wave damage. (CCHMM 959-280A4.)

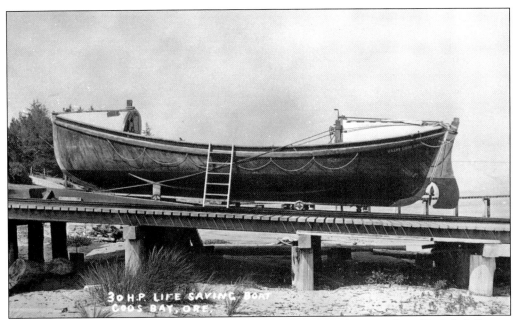

Even with a lighthouse on Cape Arago and the construction of jetties, Coos Bay's Life-Saving Service remained an essential asset to the county. As shipwrecks and small boat accidents continued to occur, the "surfmen" were prepared to risk their lives to save others. Eight paid surfmen conducted the station's first patrol on August 1, 1891. (CCHMM 992-8-0580.)

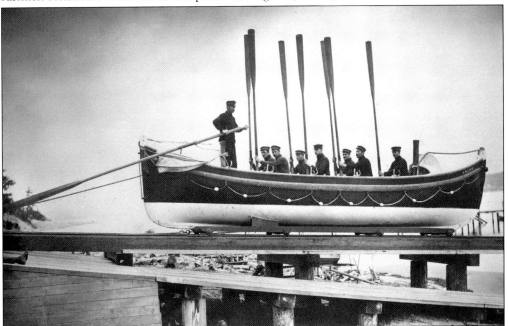

In 1891, the U.S. Life-Saving Service moved from Cape Arago to the North Spit, where it remained in operation until 1916. In 1902, it was renamed the Coos Bay Life-Saving Station and performed many valiant rescues during its 25-year history. The substantial boathouse accommodated both the keeper and his crew. From there, the men were able to launch rescue missions much more quickly than at Cape Arago. (CCHMM 992-8-0602.)

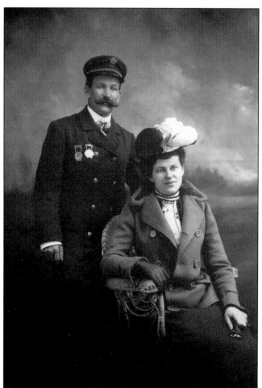

In 1871, the U.S. Life-Saving Service was formed as part of the Revenue Cutter Service by an order of Congress. Seven years later, the USLSS split from the RCS, and Oregon's first life-saving station was built at Cape Arago. Capt. Norman Nelson, seen here with his wife, commanded the site from 1990 to 1908. In 1915, the USLSS and the RCS merged to form the U.S. Coast Guard. (CCHMM 992-8-0608.)

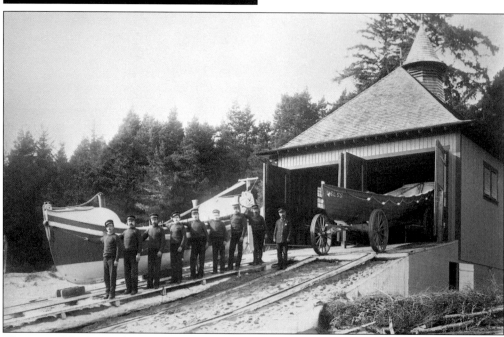

The crew of the U.S. Life-Saving Station on the North Spit kept the lifeboats in state of readiness inside the boathouse. When the alert was sounded, the boat would be released down the ramp way and into the bay. Training drills were held frequently, so that, like the boats, the men were ready for action at a moment's notice. (CCHMM 992-8-0595.)

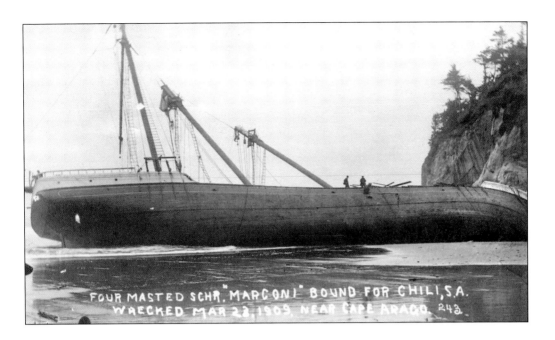

FOUR MASTED SCHR. "MARCONI" BOUND FOR CHILI, S.A. WRECKED MAR 23, 1909, NEAR CAPE ARAGO. 243

The final ship constructed at Asa Simpson's Old Town shipyard was the *Marconi*, a four-masted schooner, which was launched in 1902. Schooners were sailing ships fitted with at least two masts, the main mast being the tallest. The word derives from "schoon" or "scoon," which means "to move smoothly and quickly." The wreck of the *Marconi* on the Coos Bay bar occurred in March 1909. Ironically, the ship, which was heavily laden with lumber, was being carefully towed across the bar in order to avoid such a loss. However, the cable connecting the two vessels broke, and the *Marconi* ran aground on the South Spit. (CCHMM 985-25.35 and CCHMM 972-100P.)

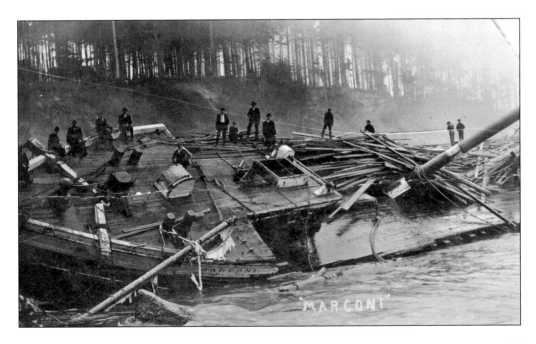

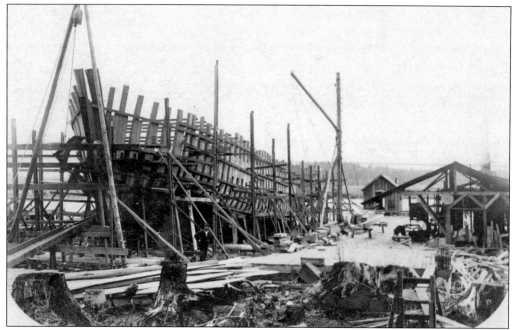

After a dispute with employer Asa Simpson, Emil Heuckendorff established his own shipyards in the Coos Bay area. Besides his yard at Marshfield, the Danish immigrant also founded the Prosper shipyard. Located close to the Coquille River, the yard produced several ships between 1905 and 1907, including the schooner *Oregon*, shown here under construction. (CCHMM 989-P302.)

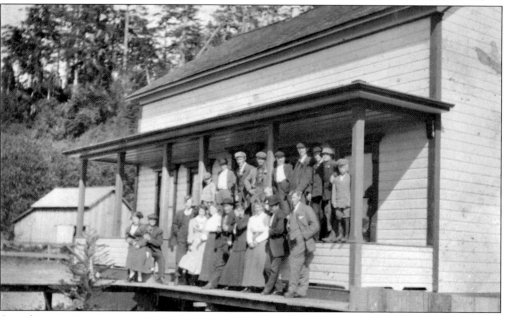

Scandinavian immigrants such as the Pedersons, who left their homeland in Norway, migrated to Coos County, where they established new lives. The Pedersons, seen here in a family portrait, not only worked at the Prosper shipyard, but they also made their living in the mines, mills, fishing, and farming. Besides Prosper, shipyards were established at Parkersburg, Randolph, Bandon, and other sites along the Coquille River. (CCHMM 997-2.10.)

Nels Nelson ran the Prosper shipyard for Emil Heuckendorff and was responsible for the construction of several vessels, including the gasoline-powered boats *Hulda*, *Escort*, *Sea Foam*, and *Buffalo*, which he built in 1905, and several fishing boats. The small boats had engines ranging from 15 to 50 horsepower in output. (CCHMM 997-2.12.)

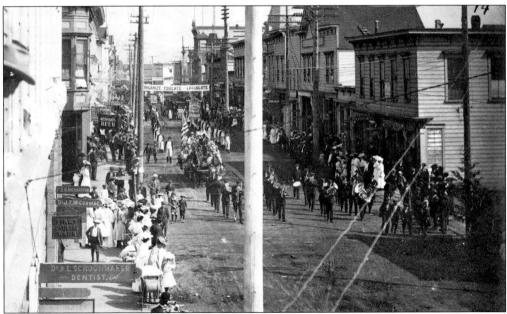

In the early 20th century, several unions formed to support shipyard workers' rights to decent wages, hours, and working conditions. On Labor Day 1907, members of the Carpenters and Joiners of North Bend and Marshfield paraded with members of other unions and coal miners to demonstrate their organizational strength and to emphasize the vital role they played in the economy of the local community. (CCHMM 968-147c.)

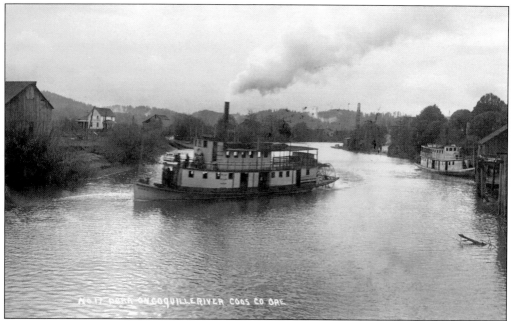

During the 1880s and 1890s, the Coquille River was navigable as far as the Johnson sawmill, which was about two miles beyond Coquille City. Coquille quickly became a busy port where steamers, such as the *Coquille* and *Dora* (shown here) and gas boats, such as the *Wolverine*, docked to receive and deliver cargo and passengers. (CCHMM 966-144.17.)

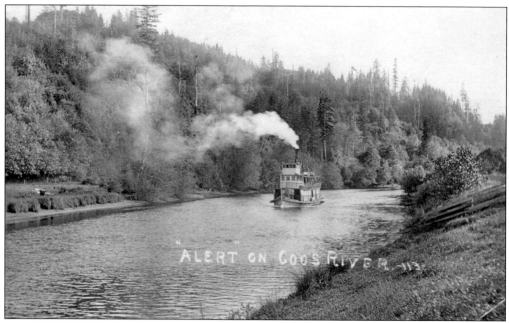

Norwegian Hans Reed built the *Alert*, a stern-wheeler, which launched from Bandon in 1888. Reed worked in several shipyards after he arrived in the area in 1872. Operating between Bandon and Coquille, the *Alert* was one of several steamers to make frequent trips up the Coquille River and was even used as a milk boat. (CCHMM 969-204j.)

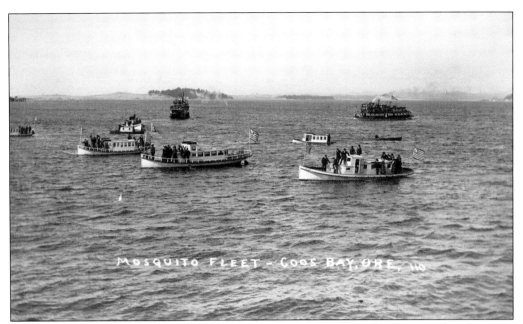

Pleasure boating was so popular during the late 19th and early 20th centuries that dozens of small craft teeming with passengers could be seen sailing county waterways. Nicknamed the "Mosquito Fleet," the variety of vessels ranged from small gas-powered boats to steamers. A charter boat service was also available. On occasion, the boats transported children to school. (CCHMM 995-17.8n.)

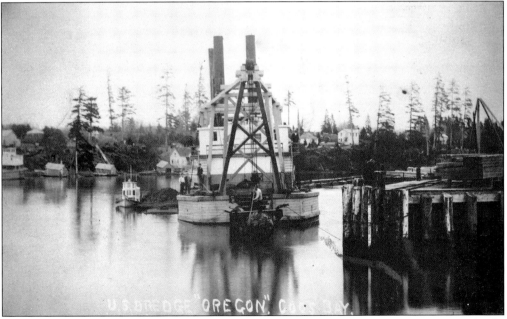

In order to ensure the easy passage of ships in and out of Coos Bay, the waterway was periodically dredged, beginning in about 1908. Materials taken from the bay were used to fill in marshes and other unstable land, which allowed Marshfield to expand its borders. Here the dredge *Oregon* makes its way across the bay. (CCHMM 992-8-0551.)

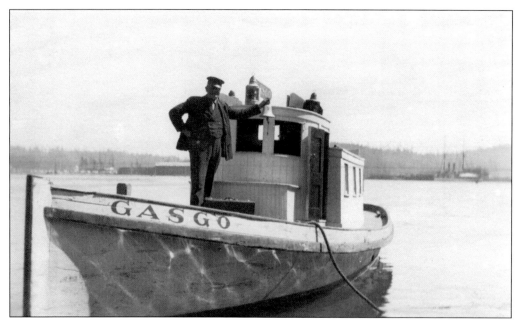

Smaller vessels were also built at shipyards near Coos Bay. At Marshfield, the Holland Brothers Boat Building Company constructed the first commercial, gas-powered boats, such as the *Gasgo*, which were more economical to run. Launched in 1900, the *Gasgo* carried passengers for the Drain-Coos Bay Stage Company and was also used as a tugboat. (CCHMM 961-33.27.)

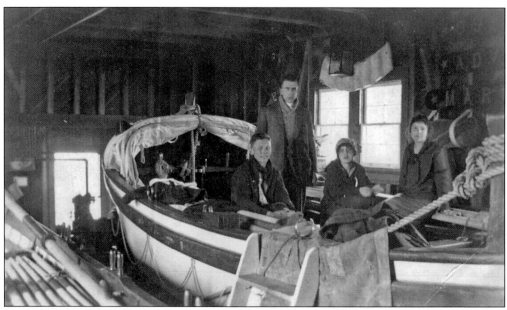

In 1916, the U.S. Life-Saving Service moved from Coos Bay's North Spit to Charleston. The boathouse, seen here in 1917, survives in excellent condition, having been taken over the Oregon Institute of Marine Biology, which restored the structure in 1975. The crew and keeper's dwellings are also still in use. (CCHMM 980-38.1.)

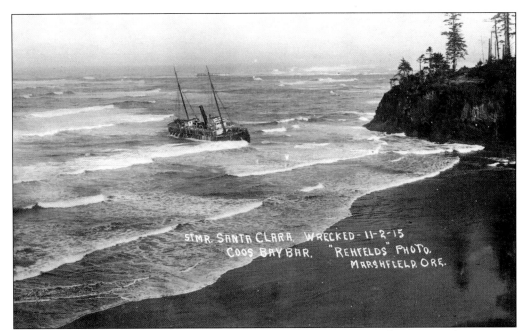

Arriving from Portland in mid-November 1915, the captain of the *Santa Clara*, a steamship carrying over 90 passengers and crewmen, tore a gaping hole in the hull as he attempted to free the ship from the Coos Bay bar. Even though most of the people made it safely to shore, the first lifeboat capsized, and eight passengers, including women and children, lost their lives. (CCHMM 961-33.15.)

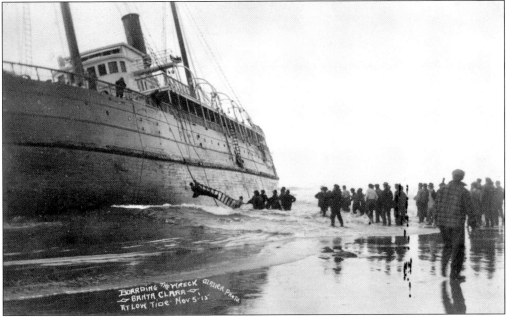

In the aftermath of the wreck of the *Santa Clara*, rampant looting overshadowed the valiant efforts made by locals to rescue, feed, and care for the survivors. The ship was stripped bare of all salvageable items, including clothes, canned goods, meat, and flour. About a week later, arsonists set fire to the *Santa Clara*, and it exploded and burned. (CCHMM 994-2.24.)

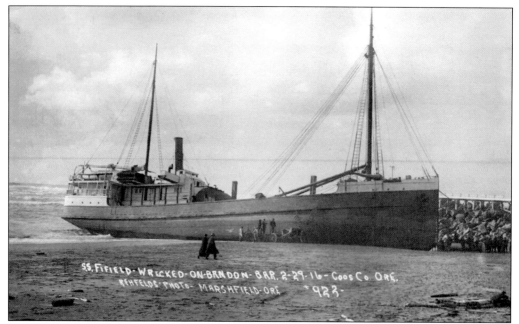

In February 1916, the *Fifield*, a steam schooner built by Kruse and Banks, wrecked during a bad weather as it tried to cross the Coquille River bar at Bandon. The storm was so severe that the ship landed on one of the jetties, which actually aided the rescue effort. The 22 crew members and four passengers survived by scrambling to safety on the jetty. (CCHMM 960-204h.)

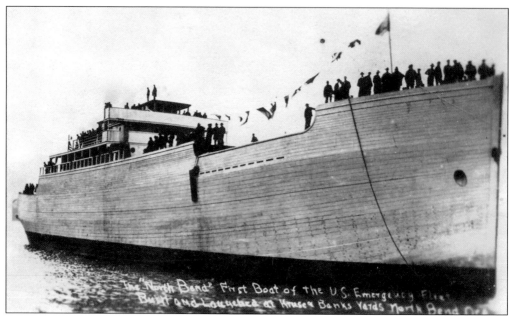

In 1917, the U.S. Shipping Board began managing the Emergency Fleet Corporation, which was tasked to build, own, and operate a merchant fleet for the government. Kruse and Banks was among the 218 shipyards nationwide contracted by the corporation to construct ships for the war effort. The SS *North Bend*, shown here, was completed within the first year. (CCHMM 976-97.)

Despite its initial success in improving shipping conditions, the North Jetty began to erode fairly quickly. In 1917, the SS *Claremont* slammed into a submerged portion of the North Jetty during the daytime. Though the ship was a complete loss, the passengers and crewmembers were rescued by the dredge *Michie*, which was operating nearby at the time. A formal request was finally submitted in 1921 to repair and restore the jetty and to erect a second jetty on the southern side of the Coos Bay bar, which had been planned but was never built. During the construction of the jetty, the local lifesaving crew kept a careful watch on the project. (CHMM 982-190.67 and CCHMM 978-28.)

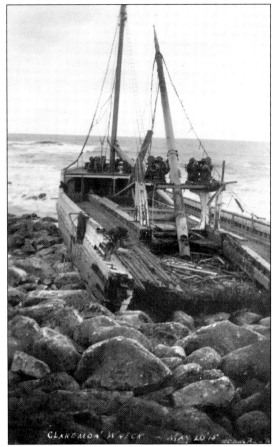

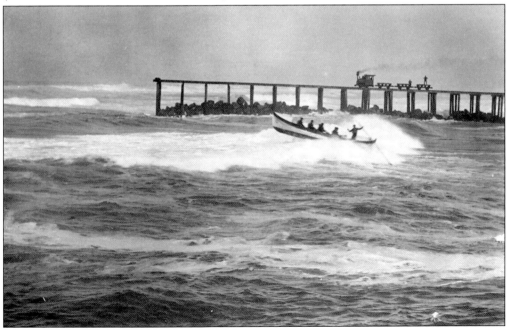

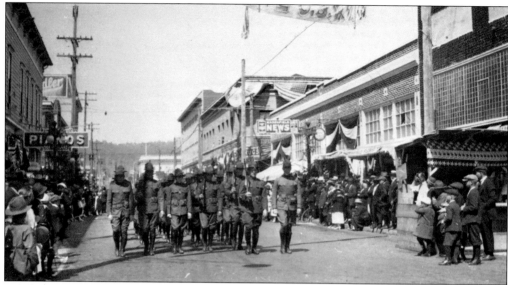

While many of Coos County's men marched to join the war in 1917 and 1918, like the 11th Company of the Oregon National Guard shown here, many others found extra work at the shipyards and in the mills. The newly created Coos Bay Shipbuilding Company and the Kruse and Banks shipyard employed some 1,000 men to meet the government's demands for new ships. (CCHMM 992-8-1159.)

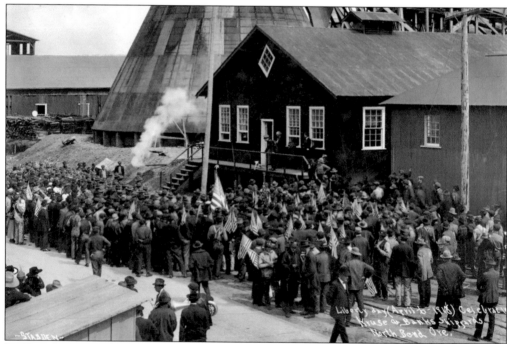

In 1918, Pres. Woodrow Wilson declared October 12 as Liberty Day. Not only did the holiday boost national spirit and encourage residents to meet their "just quota" of the Fourth Liberty Loan, the day also commemorated the 426th anniversary of the discovery of North America. Liberty Day was celebrated at the Kruse and Banks shipyard in North Bend. The shipbuilding company had its own band to celebrate special events. (CCHMM 981-284.89.0.)

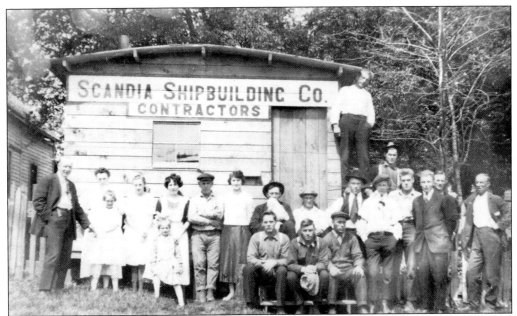

In 1919, shipwrights from Kruse and Banks and Coos Bay Shipbuilding broke away from their employers to create the Scandia Shipbuilding Company. Headquartered in Lake Oswego, the new company was never able to compete with the larger shipyards and resorted to paving planked streets in North Bend and Marshfield. In 1926, Scandia Shipbuilding closed, having built just a few vessels, including a barge and a fishing boat. (CCHMM 992-37.)

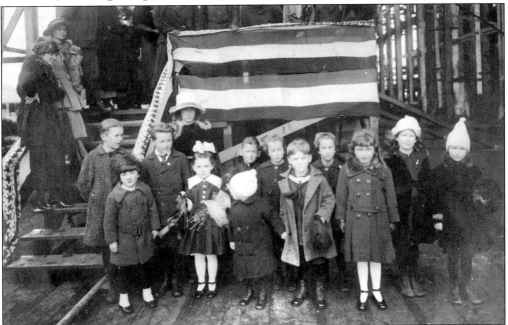

Schoolchildren celebrate the launching of the steamship *Ryder Hanify* at the Kruse and Banks shipyard in 1920. Among the participants in this photograph (not in order) are Margaret Banks, Ellen Kruse, Bernice Olson, Jack Greaves, Cyrill Lemanski, Don Platt, Anna Greaves, Eldred and Phyllis Wold, Mary Banks, and Francis Mullen. (CCHMM 999-18.1.)

The newly completed YMS 266 begins its career as one of the fleet of eight minesweepers built by Kruse and Banks in the 1940s to aid the war effort. These minesweepers were deliberately constructed with wood in order to lessen the likelihood that they would be destroyed by magnetic mines. Kruse and Banks closed down in 1946 after selling the shipyard to Weyerhaeuser the previous year. (CCHMM 981-284.93.)

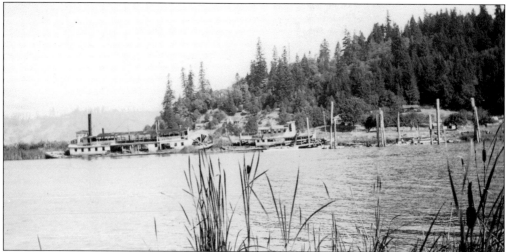

On December 11, 1948, after the *Welcome* made its final trip from Allegany to Coos Bay, commercial passenger and freight boating became a thing of the past. Many riverboats had already been discarded along the waterways near Coquille, as seen here in 1942. Others were converted for use as tug or fishing boats, and they remained in service for many years. (CCHMM 969-180.)

# Five

# FARMING AND FISHING

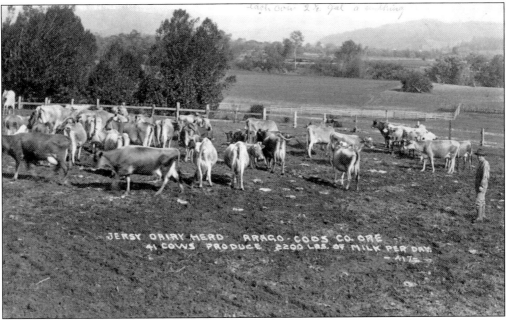

Coos County's first herd of cattle may have arrived as early as 1853. Shortly thereafter, dairy farms began appearing along both the Coos and Coquille Rivers. Almost as quickly, creameries and cheese factories were built to handle butter-making and cheese production, and condenseries were also constructed. The milk that supported these efforts arrived via boat. Today the county ranks ninth in the state in dairy production. This photograph shows a herd of Jersey cows at Arago. (CCHMM 985-28.4.)

The majority of pioneers and settlers who migrated to Coos County lived on farms and ranches away from the main towns. Important crops included hay, grains, and potatoes, and the rich pastures were ideal for grazing livestock. The John Olson homestead near North Bend was just one of many that dotted the region. (CCHMM 967-121n.)

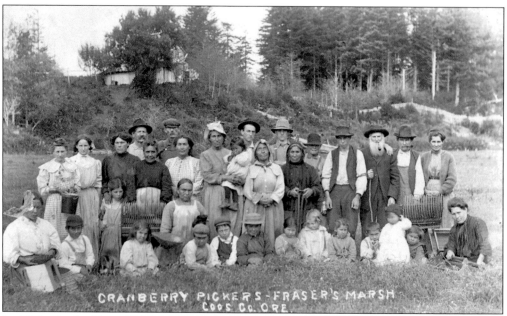

In 1885, Charles D. and Thomas H. McFarlin purchased 55 acres of land along North Slough, at what is now Hauser. Shipping cuttings from their home in Cape Cod, Massachusetts, they planted the first cranberry bog the following year. Charles McFarlin hired locals to harvest the cranberries, including Miluk Indians from Tar Heel Point, several of whom are shown here with McFarlin, who sports a long white beard. (CCHMM 959-246m.)

Originally called the "crane berry" by Dutch and German settlers who thought that the plant resembled the head and bill of a crane, cranberries were actually consumed by local Native Americans well before the arrival of Lewis and Clark in 1804. Charles McFarlin touted his venture as "mining for red gold." Today southern Coos County produces over seven percent of the nation's total cranberry crop. (CCHMM 973-90q.)

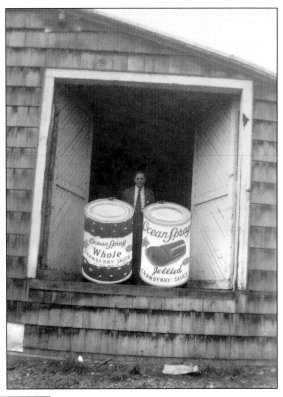

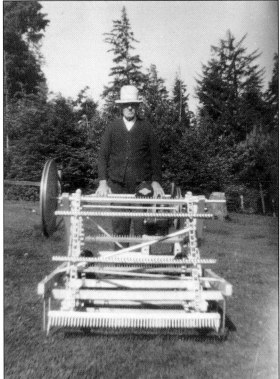

Cranberries were originally harvested by hand using a "scoop," a wooden basket with wooden teeth that "combed" the vines, removed the berries, and dropped them into the basket. Adopted for widespread use after World War II, cranberry-picking machines now comb dry berries from the vines, dump them into a burlap bag, and prune the vines. This machine is on display at the Coos County Historical and Maritime Museum. (CCHMM 973-90M.)

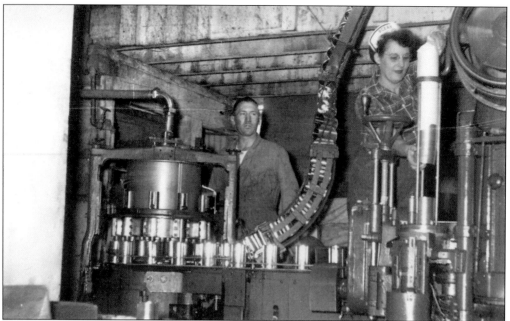

During the early 20th century, only about eight cranberry bogs existed in Oregon. After harvest, the berries were sent to processing plants in Bandon and Coquille, where they were sorted and stored for canning and shipping. The National Cranberry Association had its cannery in Coquille and marketed their product under the Ocean Spray label. Ocean Spray expanded to include growers in the Pacific Northwest in 1946. The American Cranberry Exchange shipped berries in cellophane bags from its receiving station in Bandon, using the brand name Eatmore Cranberries. Today some 2,500 acres in southern Oregon are dedicated to the crop. Among the newest ventures in cranberry production, the Coquille Indians are growing 100 percent organic cranberries on reservation land. (CCHMM 973-90O and CCHMM 973-90N.)

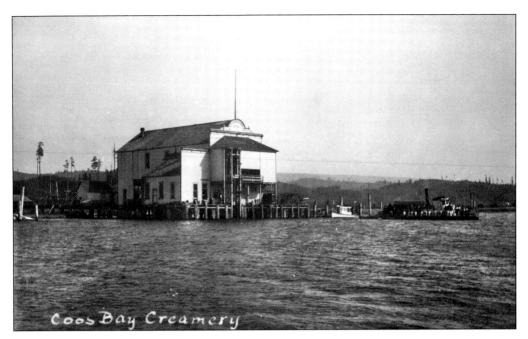

Coos Bay Creamery

Located near the mouth of the Coos River on the Dan McIntosh ranch, the Coos Bay Creamery Association was established in 1892 to provide dairy farmers with a centrally located creamery and cheese factory from where their products could be shipped to distant markets. Later called the Coos Bay Mutual Creamery Company, the Coos Bay Creamery proved highly successful. Dan McIntosh was the first creamery manager, and the operation of the factory remained in his family for over two decades. Even though fire forced the creamery to close in 1919, by then Coos Bay had achieved a widespread reputation for its fine dairy products. (CCHMM 992-8-0081 and CCHMM 988-P89.)

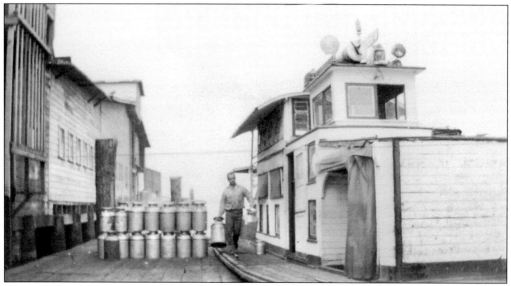

For years, Coos County residents relied on the rivers and their tributaries not just to travel but also to receive supplies and send goods to market. Dairy farmers would load 5-gallon milk containers onto boats, such as the *Favorite*, for delivery to the Coos Bay Creamery and other sites. Milk runs were common sights in the bay area. (CCHMM 001-10.5g.)

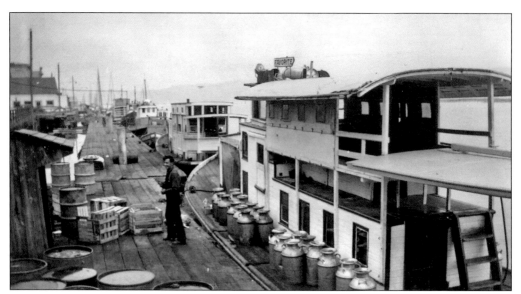

The milk boats (such as the *Favorite*, shown here) often stopped at boat landings along the county waterways so that private residents could fill 1-gallon cans with milk for home use. Steamers and stern-wheelers frequently transported milk cans to creameries, cheese factories, and the condenseries, all of which were dependent on the product. (CCHMM 001-10.5f.)

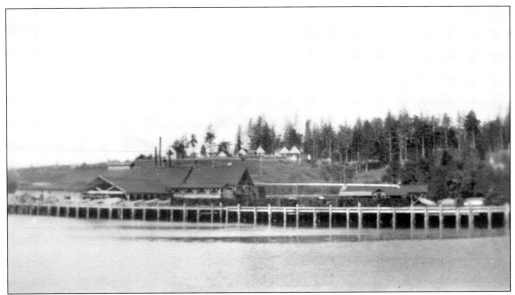

Located along the North Bend waterfront, the Coos Bay (or Sunrise) Condensery opened in 1904. Transforming fresh milk into a condensed version, the condensery sold the product under the Sunrise label. In business for about 15 years, the condensery employed seven men and could process over 17 million cans in a single year. In Bandon, the Nestle Condensery carried out the same process alongside the Coquille River. (CCHMM 981-313.23.)

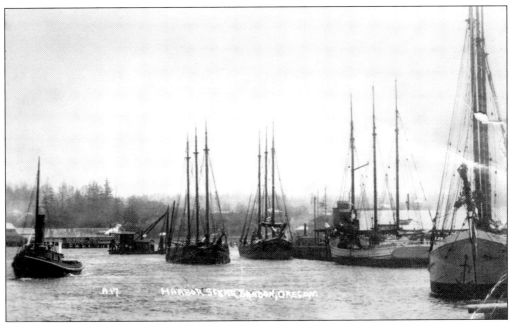

The first pioneer to fish the Coquille River for commercial purposes was John Flanagan, Patrick's brother, who discovered the rich food source while gold mining near Randolph in 1860. He quickly purchased a boat and began salmon fishing in earnest. Soon fisheries and canneries opened, and a fishing fleet sailed into the port of Bandon on a regular basis. (CCHMM 962-21e.)

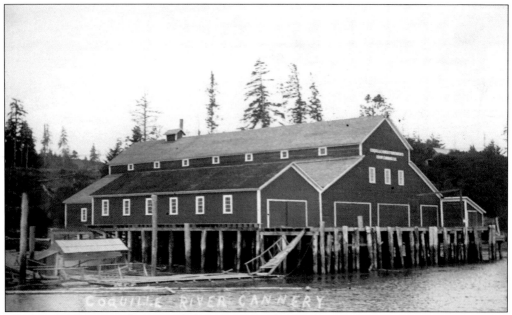

The bountiful rivers and ocean-side location primed Coos County for success in the commercial fishing industry. The Coquille River Fishermen's Co-operative Cannery opened in 1908. Located opposite Randolph Slough on the south bank of the river, the cannery processed salmon, which fishermen caught using seines, large nets laden with sinkers pulled through the water by horses. (CCHMM 966-114.15.)

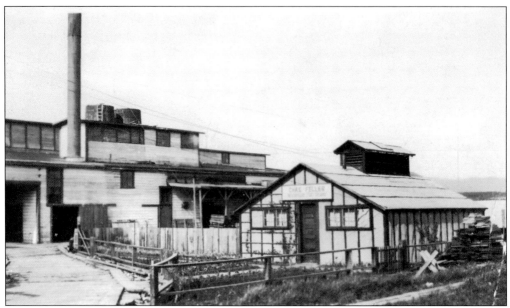

Improving transportation links with the world outside of Coos Bay proved a boon for a variety of businesses, not just for the shipyards and lumber industries. Fishmongers such as Charles Feller catered to the commercial fishing industry, purchasing fresh fish and preparing them for shipping both in the United States and overseas. The fish dealer built his plant on Front Street in Marshfield, where it proved quite successful. (CCHMM 987-39.)

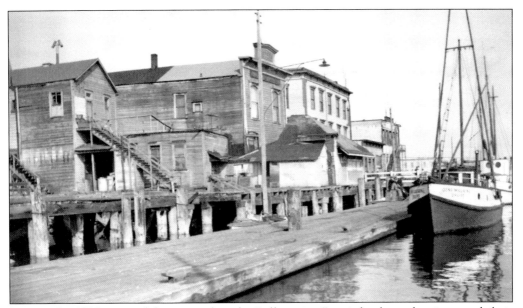

During the 1880s, most fishing was done by "gill-netting," mainly along the rivers and their tributaries. Two decades later, after the introduction of gasoline engines, fishing boats began heading to the ocean to troll for salmon and other fish, such as halibut, which were increasingly becoming a marketable commodity. (CCHMM 001-10.5d.)

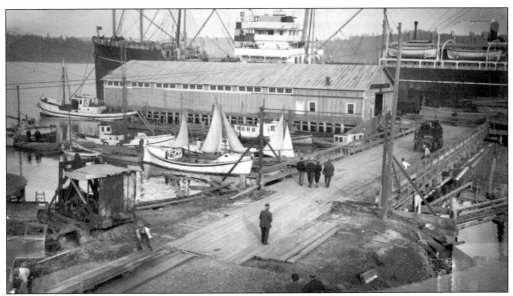

Fish processing and canning began along the Coos River and at Empire in the 1880s; Marshfield followed a decade later. Fishing boats sailed directly alongside the Marshfield waterfront, where they unloaded their day's haul. Salmon fishing dominated the region until the 1930s. In North Bend, the main center for the fishing industry was at the end of Virginia Street, where companies such as Oregon Pacific had their docks. (CCHMM 989-P333.)

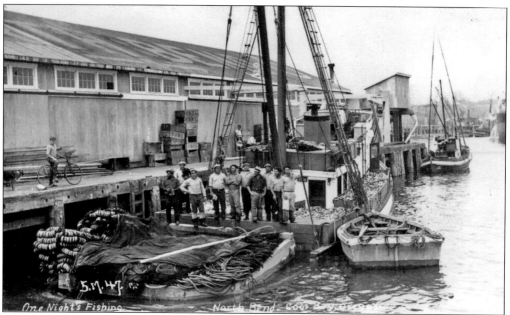

During the 1920s, Coos County's commercial fishing industry flourished. Scores of fishing boats trolled the waters along the Pacific Coast. Many of them sailed into the bay to dock at North Bend. Each day's haul could be enormous. One of the best years was 1928, when about 1,106 tons of fish were taken from the rivers and coastal waters. (CCHMM 960-204g.)

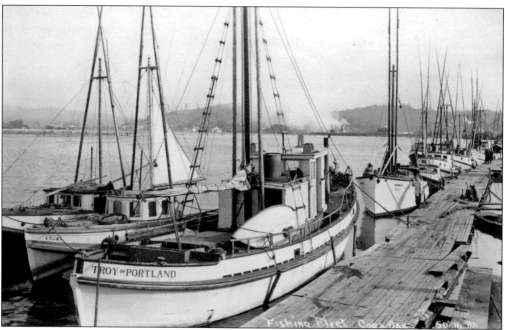

Fishing boats, such as the *Troy of Portland*, shown here with other boats in the local fishing fleet, caught shad, striped bass, and albacore tuna, which they hauled into port for processing and delivery to distant markets. Prior to the construction of the canneries, fish were salted and loaded into barrels and then shipped to San Francisco. (CCHMM 986-16.4.)

From 1935 to 1937, the pilchard industry boomed in North Bend. Fisheries were established and floating reduction plants processed the fish oil, which was transferred into railroad tank cars or onto boats for shipping elsewhere. The pilchard fleet, including the *Portland*, sailed immediately alongside the plants, which measured several hundred feet in length, to unload their catch. (CCHMM 001-10.5b.)

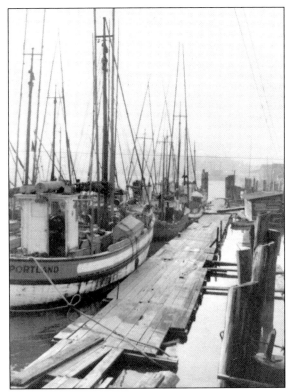

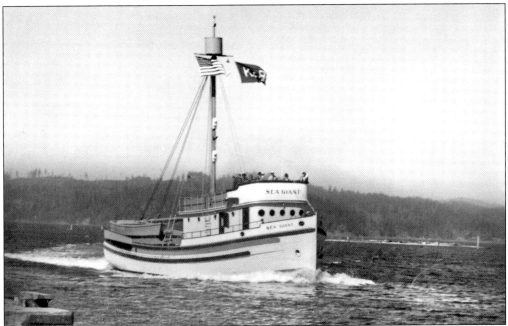

Oregon's first purse seiner, the 86-foot-long *Sea Giant*, was constructed at the Kruse and Banks shipyard and set sail in 1935. By the time the pilchard industry foundered in 1937, the fleet of purse seiners had taken in a haul of 26,227 tons of the fish, which are also known as Pacific sardines. (CCHMM 981-284.88.0.)

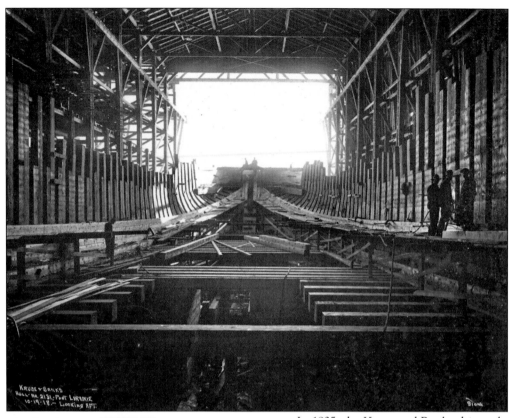

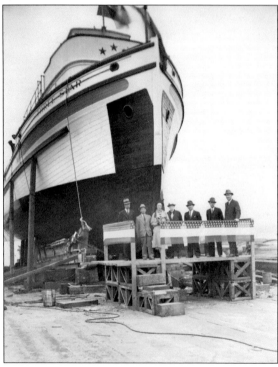

In 1935, the Kruse and Banks shipyard began building a fleet of purse seiners, ships specially designed to catch pilchards as they headed northwards along the Pacific Coast. They acquired their unusual designation from the purse-like shape their fishing nets (the seines) took on after they closed on a catch of pilchards. Kruse and Banks's second purse seiner, the *Three Star*, was launched in 1937. One of the last of its kind to be constructed at Coos Bay (the run of pilchards lasted only three years), the 83-foot-long *Three Star* ended up in California, where it was used for tuna fishing. (CCHMM 981-284.90 and CCHMM 981-284.86.)

*Six*

# ROADS, BRIDGES, AND RAILROADS

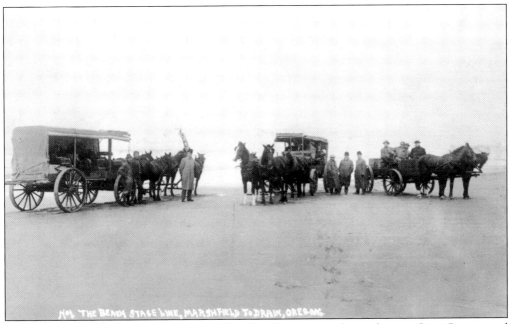

Before the coastal highway was constructed and roads were paved, travel across Coos County and to points north of the bay often involved heading to the shore, where beaches, relatively clear of obstacles, stretched for miles. In 1854, the Beach Route, which ran from Empire City to Tenmile Creek, was designated as Coos County's first official road. It was widely used by the Beach Stage Coach Line, shown here. Problems did occur, and the vehicles could find themselves mired in mud. The local pioneers, who had journeyed across the country, were undoubtedly quite familiar with such situations. (CCHMM 987-30.1.)

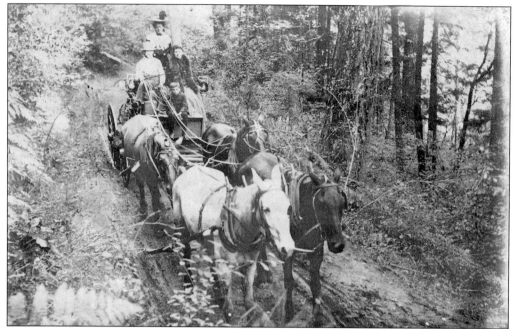

The Coos Bay Wagon Road passed from Roseburg in the east through the towns of Lookinglass and Ten Mile, over the coastal range at Camas Mountain (seen here), to Sitkum, and onward to Sumner. No matter the time of year, travel was perilous and accidents—but only one fatality—occurred. (CCHMM 962-57d.)

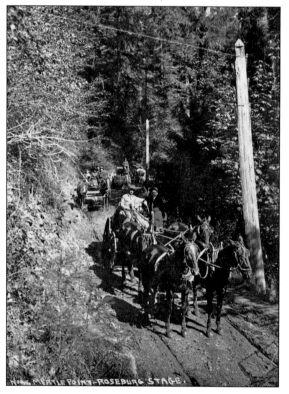

The Coos Bay Military Wagon Road, completed in 1873, was intended to ease the arduous journey between the coast and Roseburg, a distance of about 85 miles. But it remained challenging at best, especially in rainy weather. Stagecoaches, thought to be more comfortable, finally replaced wagon travel in 1893. (CCHMM 992-8-0013.)

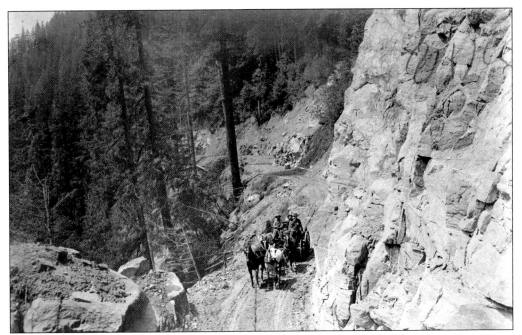

During summertime, when the weather was likely to cooperate, a trip along the Coos Bay Wagon Road could be expected to take 12 hours, one way. Each four-horse coach carried the day's mail, the driver, 11 passengers, and their belongings. In addition to the $6.25 fare for the one-way trip, a small fee was charged for excess baggage. (CCHMM 992-8-0005.)

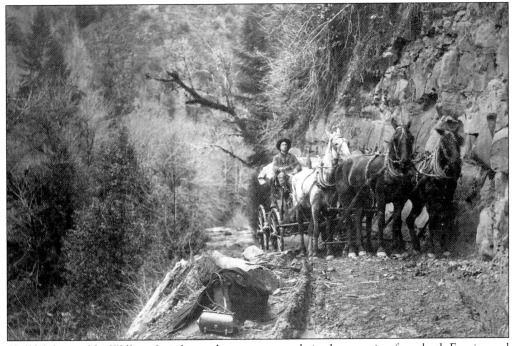

Skillful drivers like William Laird, seen here, set out early in the morning from both Empire and Roseburg to make sure the stages reached their final destinations at the end of the day. The trip along the narrow road often involved driving perilously close to the edge. (CCHMM 992-8-0010.)

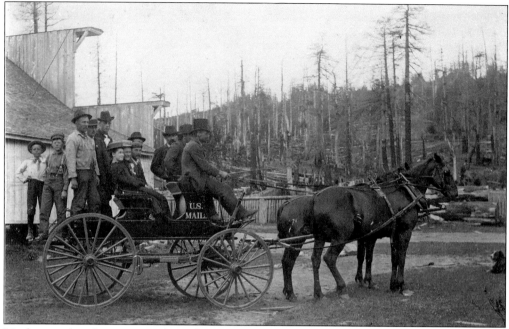

Hauling mail and passengers along the Wagon Road and the Myrtle Point–Roosevelt Highway strained both the drivers and their horse teams. Stopping points at Bridge, Remote, Camas Valley, Olalla, Brockway and other sites allowed the drivers to rest, have a meal, and obtain fresh horses. This mail stage is on its way through Coquille. (CCHMM 992-8-0002.)

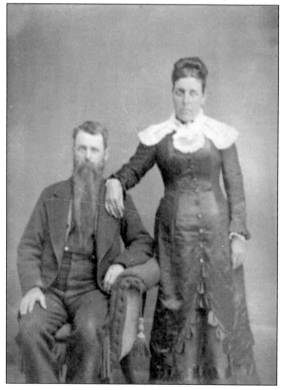

James and Chloe Laird, who married in 1875, operated a tollgate, the post office, and the Halfway House in Sitkum, a popular stopping point on the wagon road, which no longer survives. Several of the couple's children were also involved in running the inn and manning the stagecoach to deliver mail and carry passengers across southern Oregon. (CCHMM 005-1.72.)

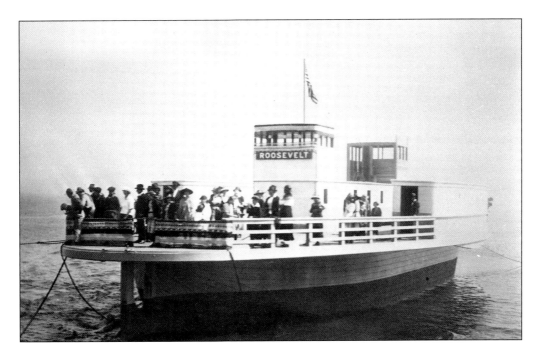

Travel from the south coast to points north was hindered by the presence of the bay and its adjoining estuaries. Even though the railroad was on its way, travelers needed an alternative means of crossing the waterway. In May 1922, the *Roosevelt*, a steam-powered side-wheeler, ferried its first load of passengers and automobiles across the bay. It made hourly trips between North Bend and Glasgow during summer months. Eventually the *Roosevelt* was stripped, towed up Isthmus Slough, and abandoned. The ferry's wooden nameplate is on display in the Coos County Historical and Maritime Museum, located not too far from where it once docked. The rotting hull is still visible alongside Highway 101. (CCHMM 963-45 and CCHMM 992-8-0866.)

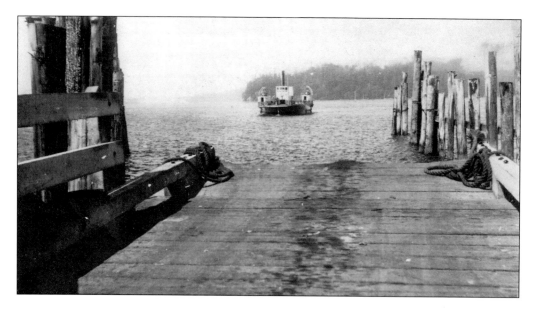

Prior to the completion of the Coos Bay (McCullough) Bridge in 1936, anyone wanting to journey farther north along the coast took the *Roosevelt* ferry across Coos Bay. Able to carry only 12 cars plus passengers, the *Roosevelt*, built at the Kruse and Banks shipyard, was placed on standby when the *Oregon* began its ferry runs in late 1929. Driven by a diesel engine with screw propellers at each end, the new ferry could carry up to 36 cars across the bay between North Bend and Glasgow. The *Oregon* made its final trip in May 1936. A ferry service also crossed the Coquille River near the site of the present Bullards Bridge. (CCHMM 970-23b and CCHMM 977-101.175.)

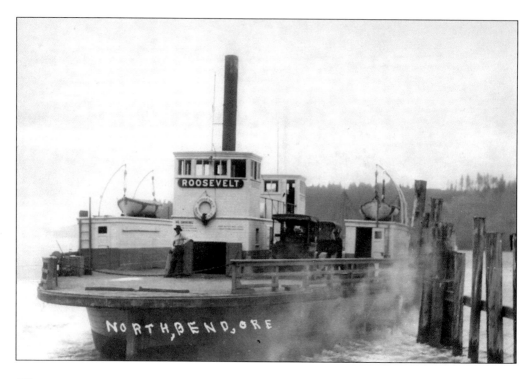

Even though the motorcar was a technological advance over the horse-drawn stagecoach, it took five years from when the first car made its way along the Coos Bay Wagon Road in 1908 to establish a regular passenger service for travelers wanting to reach the coast. A motor stage line also ran between Marshfield and North Bend. (CCHMM 975-34s.)

Besides the beach road along the coast and the wagon road that headed inland across the coastal range, the only other reliable roadway was a link from Marshfield to Coquille. The narrow road eventually became part of Highway 42, which extends from Coos Bay to Interstate 5, not too far south of Roseburg, where the wagon road once terminated. (CCHMM 982-163.)

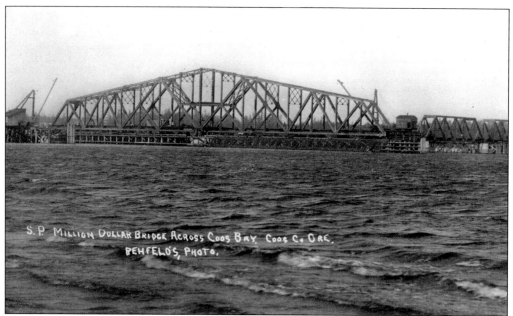

In 1912, the U.S. War Department agreed to allow the Willamette Pacific Railroad Company to build a bridge across Coos Bay. In return, the company was required not only to maintain the ship channel beneath the bridge, but also to keep the draw open around the clock, except when trains needed to cross the waterway. Even today, the Coos Bay railroad bridge remains open 24 hours a day. (CCHMM 992-8-0829.)

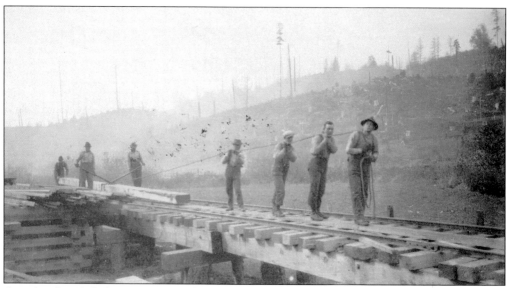

Completed in 1915, the construction of the Coos Bay railroad bridge required workers to lay horizontal "stringers," long pieces of timber, along the entire length of the bridge. Placed to help prevent the bridge from collapsing, the stringers provided structural support for the ties and tracks, including where they crossed arched areas that lacked piers to buttress them. (CCHMM 966-144-25.)

Queen of Carnival North Bend 1915

When the Coos Bay railroad bridge was completed in 1915, local residents celebrated for three days. After all, travel around the state was becoming eminently easier and, in a few months, the rail link between Eugene and North Bend would be done as well. In October 1915, the Big Bridge Carnival marked the event with marching bands and a parade with floats, one of which carried the carnival queen. In 1924, the *Martha Buehner*, a steamer owned by the Stout Lumber Company, hit the bridge. Little damage was done to the bridge, and passengers continued riding the rails three days later. (CCHMM 975-34i and CCHMM 992-8-0908.)

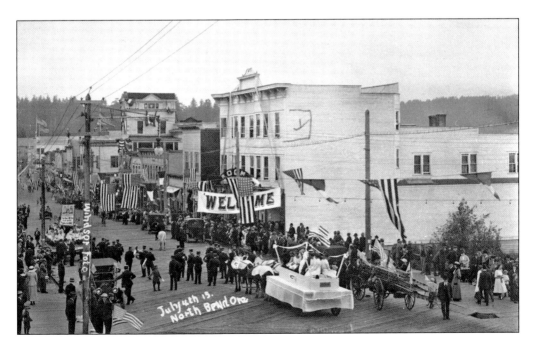

July 4th 15. North Bend Ore.

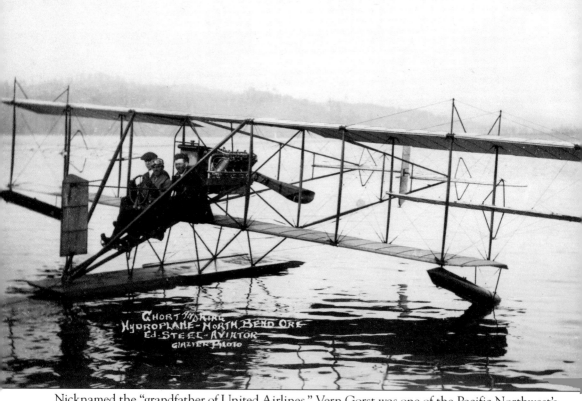

GHORST MOTORING
HYDROPLANE - NORTH BEND ORE
Ed STEEL AVIATOR
GLAZIER PHOTO

Nicknamed the "grandfather of United Airlines," Vern Gorst was one of the Pacific Northwest's great aviation pioneers. Even though much of his early career in Coos Bay focused on transporting people by car, Gorst was passionate about aviation and recognized the possibilities of opening the skies to passenger flights. In 1913, he purchased an "amphibious plane" (a Glenn Martin hydroplane) and, after making some modifications, began flying passengers from North Bend to Marshfield. A wreck in 1914 forced Gorst to postpone expanding his air transport business. Then, in 1925, he founded the Pacific Air Transport Company and began taking passengers and mail to distant points along the Pacific Coast. Five years later, Gorst suggested uniting four small airlines (Boeing Air Transport, Pacific Air Transport, Varney Air Lines, and National Air Transport) to form the United Aircraft and Transport Holding Company, which ultimately led to the formation of United Airlines. He died in 1953, having taken aviation into a new era. (CCHMM 982-190.38)

In 1912, Vern Gorst and Charles King began a motor stage line that shuttled riders between North Bend and Marshfield for a 25¢ fare. In 1920, their Coast Auto Lines became the first passenger service from Coos Bay to stop at points along the Oregon Coast on its way to Crescent City, California. Vehicles used by Gorst and King included a six-passenger Cadillac and a Volkswagen Bus. (CCHMM 989-P80.)

In 1919, Oregonians decided it was time to construct a road along the coast that would not only ease routine travel, but also would provide essential support, if needed, for the military. The Theodore Roosevelt Coast Military Highway was completed in 1936. Now known as Highway 101, the Oregon Coast Highway stretches the entire Pacific coastline. (CCHMM 986-14.3.)

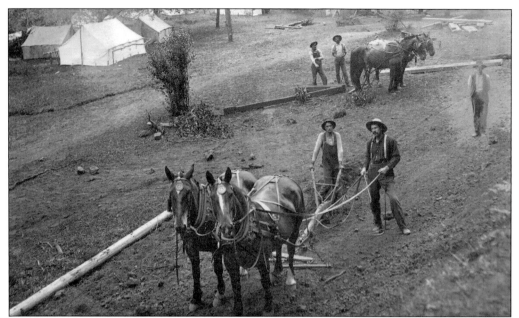

To provide for the construction of roads and highways in Oregon, Chapter 423 of the Oregon Laws of 1917 determined that "a road from Roseburg by Myrtle Point and Coquille" should be constructed. The Oregon State Highway Commission named this route the Coos Bay–Roseburg Highway and designated it a primary highway on November 27, 1917. Construction was labor-intensive and involved human and animal power. (CCHMM 959-317c.)

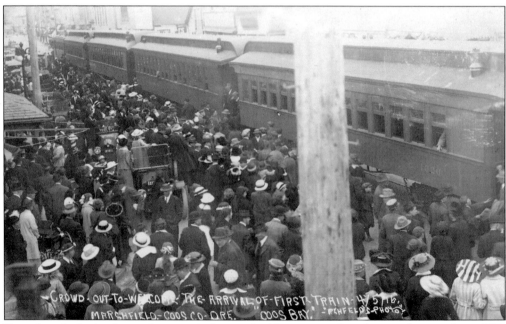

Even though the lumber and mining industries had been using short-line tracks as early as 1870, it was not until April 5, 1916, that first passenger train on the Willamette Pacific Line arrived in Marshfield. Built by the Southern Pacific Railroad Company at a cost of $10 million, the railway linked the south coast to Eugene. It was soon renamed the Coos Bay Line. (CCHMM 960-17.)

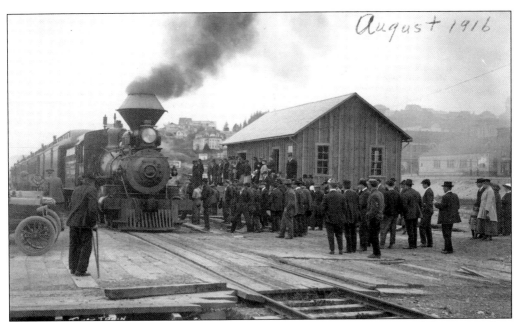

August 1916

Merging with the Marshfield to Myrtle Point link completed in 1893 by the defunct Coos Bay, Roseburg, and Eastern Railroad and Navigation Company, the Coos Bay Line ran from Eugene through Marshfield all the way to Powers. Trains had one passenger car and one parlor car; overnight passengers could opt for the additional sleeper car. This image shows the train on its first day. (CCHMM 982-190.32.)

To celebrate the completion of the Willamette Pacific Line, Coos County residents organized a railroad jubilee. Among the highlights was the "mock" wedding of Mr. Eugene Lane and Miss Coos Bay, which symbolized the linking of the two areas. Two of the participants, Mr. Willamette and Miss Coast, who is wearing Native American ceremonial garb, also represented the new connection between the regions. (CCHMM 968-135.)

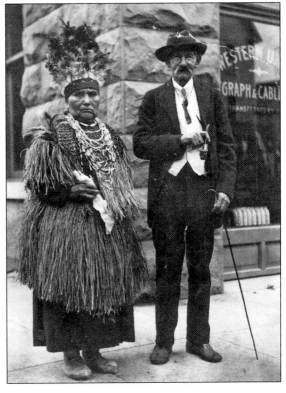

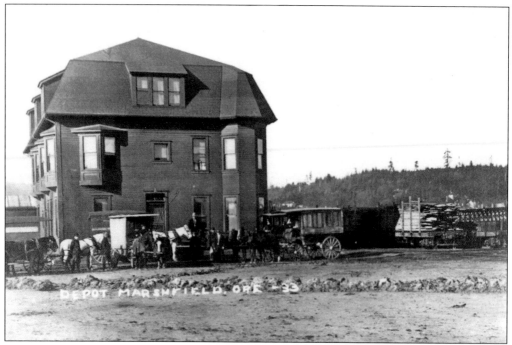

Providing support services for the Southern Pacific's Eugene to Marshfield line, the Marshfield station housed offices and a dispatcher. The terminal at Myrtle Point featured a train order office and a turntable for return trips to Marshfield and back to Eugene. Passenger services between Eugene and Coos Bay ended in 1953. (CCHMM 977-101.122.)

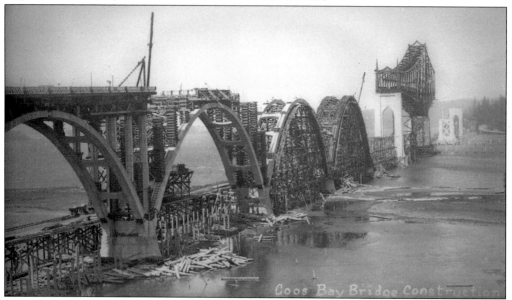

Begun in 1934 under an agreement between the Oregon State Highway Commission, the Northwest Roads Company, and Virginia Bridge and Iron Works Company, the Coos Bay Bridge was a FEMA project. The bridge features a 1,708-foot-long steel cantilever span placed at the center of 13 concrete arches. Current plans are to give the bridge a much needed touch-up with paint, a coat of zinc, and road repairs. (CCHMM 992-8-0870.)

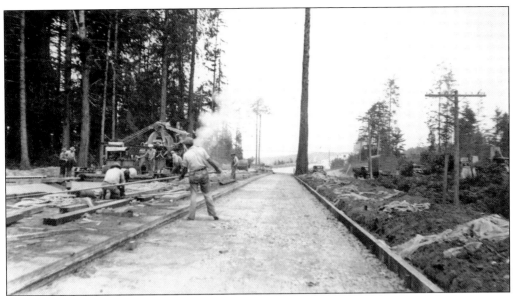

Constructing the lengthy Coos Bay Bridge was no simple task. Northwest Roads built the piers and approach ways, and Virginia Bridge added the steel spans. During 1935, two men fell to their deaths while working on the bridge, but construction carried on. The opening ceremony in 1936 was dedicated to Asa Simpson, whose sons attended the celebration. (CCHMM 992-4.7.)

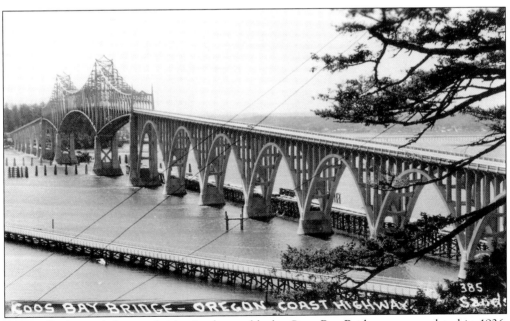

Reputedly the sixth longest bridge in the world, the Coos Bay Bridge was completed in 1936. The last and largest of the five bridges designed by Conde B. McCullough for the Oregon State Highway Department, it is just over a mile long. In 1947, the concrete and steel structure was renamed the McCullough Memorial Bridge. A plaque on the southeastern side of the bridge honors its designer. (CCHMM 986-14.2.)

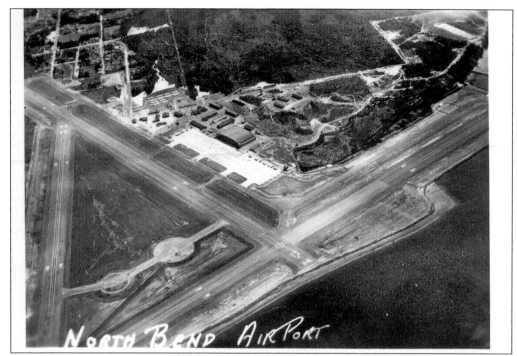

During the 1930s, two sites vied to become the county airport. In the end, North Bend won out over Eastside. In 1932, the North Bend, Coos Bay, Oregon Airport officially opened to the public. During World War II, the U.S. Navy used the airport as an auxiliary air station. Once known as the North Bend Municipal Airport, it is now called the Southwest Oregon Regional Airport. (CCHMM 982-191.42.)

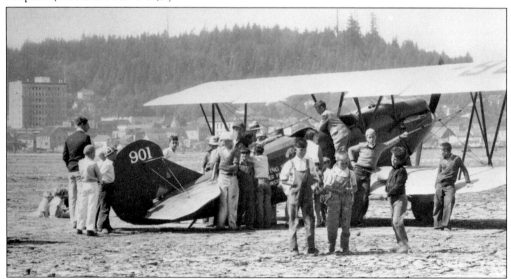

In 1931, the Port of Coos Bay signalled its support of the Eastside airport as the county's airport by leasing the site, which they called the Coos Bay Airport. Operational for several years, the Eastside airport had plenty of space to operate a regular service. Barely a year later, the North Bend airport became the county's official airport and the Eastside site, seen here, was dismantled. (CCHMM 992-8-1162.)

# Seven

# THE LATER YEARS

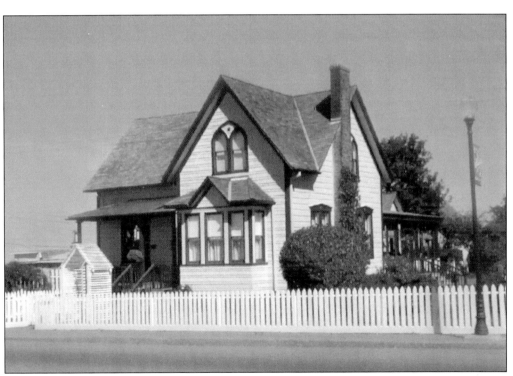

The historic Tower-Flanagan house in Empire has been on the National Register of Historic Places since 1984. Built in 1868 by Dr. Charles W. Tower, the house served as his residence and medical office. In 1874, Patrick Flanagan purchased the house and the Towers moved to a new home. Flanagan lived here until his death in 1896. He is buried in the Empire pioneer cemetery, which is located a short distance away. The Confederated Tribes of the Coos, Umpqua, and Suislaw Indians now maintain the site. (Courtesy Thomas and Stephanie Kramer.)

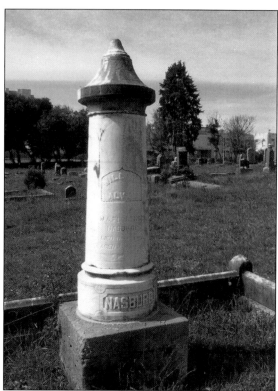

The Marshfield IOOF cemetery is the final resting place for many of the county's notable early citizens, including the Nasburgs, whose monument is shown here, as well as Esther Lockhart, Charles Merchant, Henry Sengstacken, and members of the Flanagan, Kruse, and Hirst families. Many of the monuments remain in excellent condition. Some stones have slumped downhill due to their position and the effect of ground subsidence. (Author's collection.)

The charming Joseph W. Bennett house on Alder Avenue in Coos Bay has stunning views of central Coos Bay and beyond to Isthmus Slough. The son of Lord George Bennett of Bandon, Ireland, Joseph was a successful attorney and co-owner of the Flanagan and Bennett Bank on Front Street. Lord Bennett was one of the original founders of Bandon, Oregon. (Author's collection.)

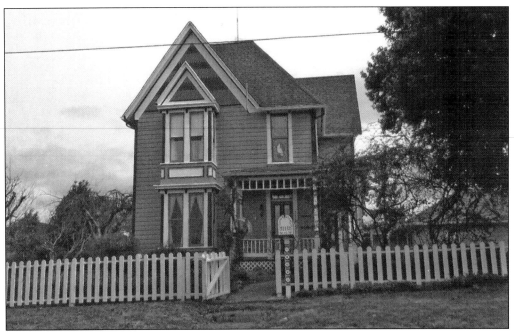

The William A. Border house dominates a hilltop overlooking Myrtle Point. Dating to 1887, the residence was situated not only for fine views of the surrounding countryside, but also for a view of Myrtle Point. From the house, Border could watch the activity at the Myrtle Point Hotel, which he managed. With associate Edward Bender, Border platted the eastern addition to the town. (Author's collection.)

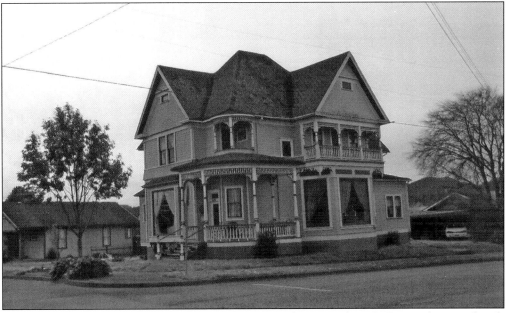

Arguably the most impressive of Myrtle Point's historic homes is the J. R. Benson house, a lavish Queen Anne–style home that dates to the 1890s. Owned by entrepreneur J. R. Benson, who founded the Bank of Myrtle Point in 1901 and served as the town's first bank proprietor, the house sits in the center of town well within view of W. A. Border's house on the hill. (Author's collection.)

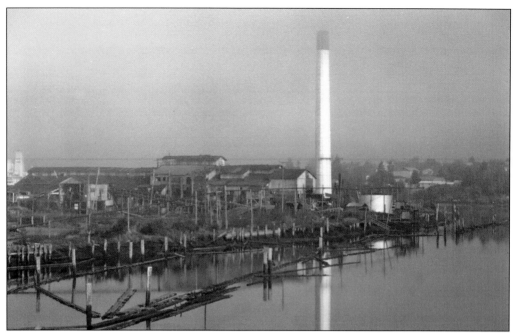

For several years after the end of World War II, Coos County's lumber industry prospered as orders for lumber to rebuild war-torn Europe inundated the mills. In 1947, the county was touted as the lumber capital of the world. By 1952, a spate of new mills appeared. Four years later, the Georgia-Pacific Corporation (top) bought the Coos Bay Lumber Company (formerly the C. A. Smith Logging Company) and tripled their timber harvests. By 1979, forests were severely depleted. Mills, including Georgia-Pacific's, closed, and scores of jobs were lost. In 1980, two of the oldest operations, Cape Arago Mill and the Coos Head Timber Company (below), closed, which forced some 400 workers to find new employment. (CCHMM 992-8-0817 and CCHMM 999-D36.19.)

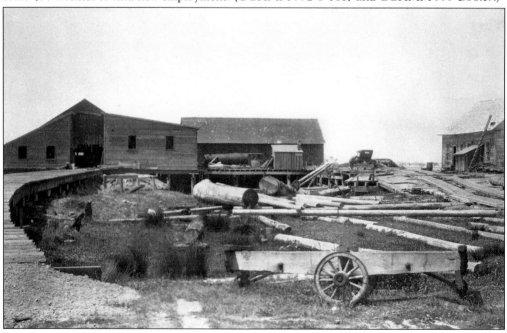

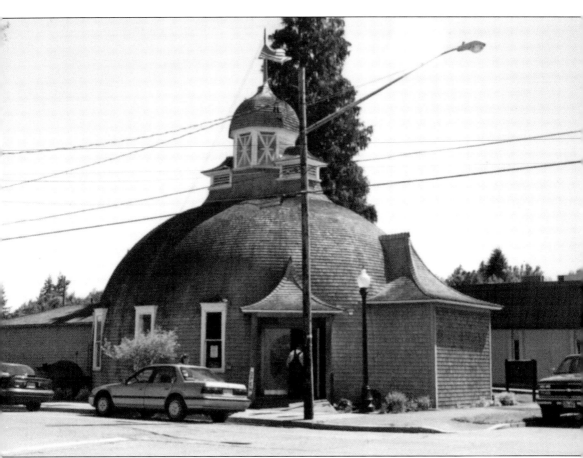

Built in 1910 as a church, the Coos County Logging Museum in Myrtle Point sports an onion-domed, Russian Orthodox–style roof. It was designed by members of the Reorganized Church of Latter Day Saints, whose congregation modeled the structure on the Mormon Tabernacle in Salt Lake City. Designers intended the building to have ideal acoustics, and even today conversations on one side of the museum can easily be heard across the room. Well-planned exhibits cover the history of Coos County logging. Displays include heaps of old picaroons, log jacks, peavies, iron falling wedges, and an exhibit of wooden yokes and bull blinders. A small niche pays tribute to those who have lost their lives laboring in the forests. Books and plaques list names, dates, and causes of death for scores of men and women who worked in the logging industry. (Author's collection.)

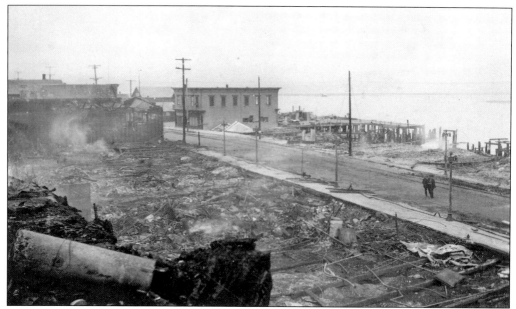

Fires ravaged the county's coastal cities on several occasions, forcing residents to rebuild not only their homes, but businesses as well. In 1922, Front Street in Marshfield (seen here) suffered such a disastrous blow that it never fully recovered. In total, 23 businesses were destroyed. In 1936, only two buildings escaped the great Bandon fire, which burned areas of Coos County as far north as Cape Arago. (CCHMM 966-151g.)

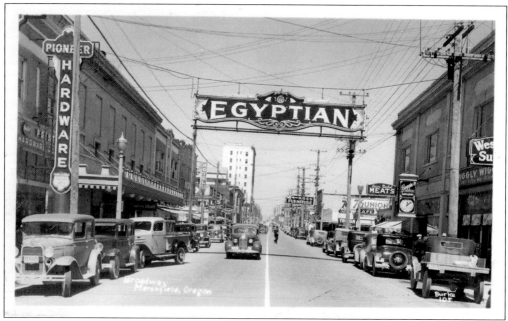

After the Front Street fire of 1922, Marshfield's central business district was reestablished around Central Avenue, where the new city hall was constructed in 1923. The southbound lanes of Highway 101 now pass through what was once known as Main Street. Among the new buildings, the Egyptian Theatre was erected in 1925. It still operates in its original location. In 1944, Marshfield acquired a new name—Coos Bay. (CCHMM 997-D18.)

The last vestige of Marshfield's original Front Street business district is the Sun Printing Museum, which occupies a street corner near the waterfront. Inside a fascinating array of items, including printing presses, fill the building where Jesse A. Luse, grandson of pioneer entrepreneur Henry Heaton Luse, first published the *Sun* newspaper in 1891. He kept the locals informed of the latest events until 1944. (Author's collection.)

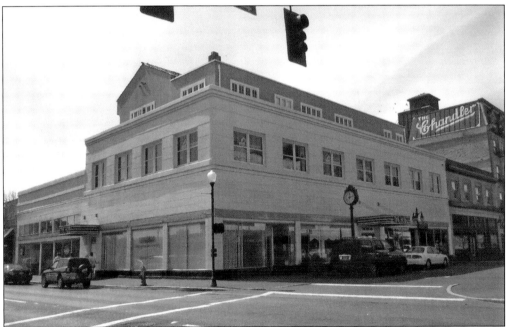

Marshfield's earliest clothing store, The Hub, stands squarely in the center of Coos Bay next to the Chandler Hotel and annex, which are listed on the National Register of Historic Places, and other noteworthy structures in the Marshfield historic district. The original Hub was a smaller store located on Front Street and was rebuilt at its new location shortly after the fire. (Author's collection.)

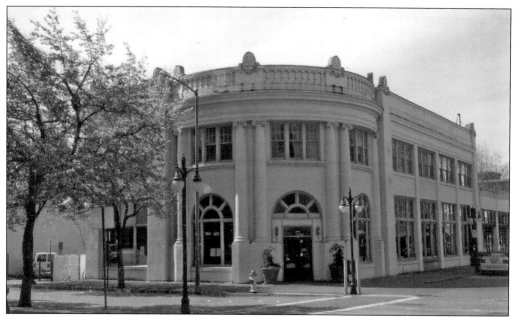

Built in the city's new business district shortly after the Front Street fire of 1922, the Coos Bay National Bank on Central Avenue is located near the old city hall. Designed by architect John E. Tourtellotte, the bank's well-preserved facade was done in a simplified Renaissance style. Also known as the Bugge Bank, the building has recently been used as a store and as a restaurant. (Author's collection.)

Erected in 1921, Coos County's only surviving covered bridge spans the Sandy Creek near the town of Remote. At one time, the 60-foot bridge was a thoroughfare on Highway 42, but in 1949 the road was rerouted away from the bridge. The truss bridge has been restored by volunteers and now allows visitors to cross on foot. (Author's collection.)

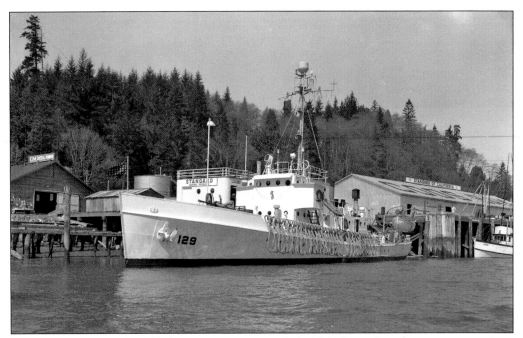

Shortly after its formal establishment in January 1915, the U.S. Coast Guard came to stay at Coos County and occupied the new life-saving station at Charleston. Today they operate a lifeboat station at Coos Bay and also an air station in North Bend. This image shows the USCGC *Bonham* and the fishing boat *Joanne* sailing the bay waters in 1948. (CCHMM 992-8-0579.)

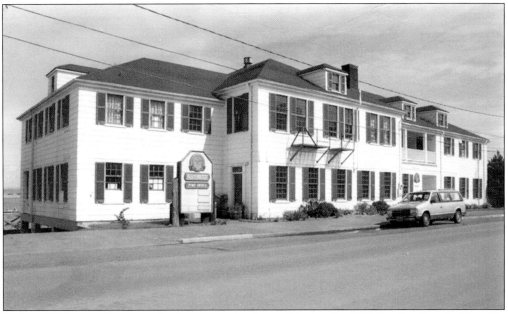

Built in 1939 as a replacement for the station that burned during the 1936 Bandon fire, the Coquille River Coast Guard Station is now occupied by the Port of Bandon, which was established in 1912, and tenants. The lifeboat station once not only contained a contingent of 17 men, who lived on the upper level, but also a lifeboat, which could be launched into the river from the ramp way behind the station. (Author's collection.)

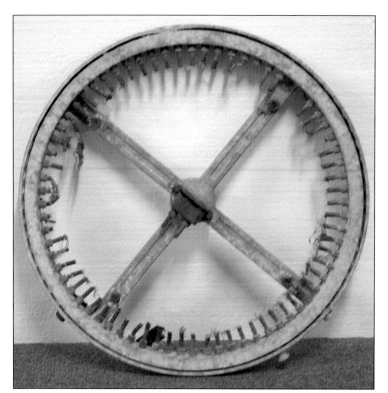

In 1942, the Japanese staged bombing raids from the I-25, a submarine with aircraft that was positioned offshore near Coos Bay. While the incendiary and balloon bombs did little damage to the forests that were their targets, torpedoes did sink two oil tankers, the SS *Camden* and the SS *Larry Doheny*, which were heading to Portland. This bomb ring is in the collection of the Coos County Museum. (CCHMM bomb003.)

The county's tallest building, the Tioga Hotel, dominates Coos Bay's skyline. Begun in 1925, construction was suspended on the project during the Great Depression and World War II but was finally completed in 1948. It is listed on the National Register of Historic Places. Among its most notable features, classical-style urns line the edges of the rooftop. (Author's collection.)

"Ensuring a Future for Our Past" is the motto of the Oregon Coast Historical Railway, whose members created a display area and museum along the Coos Bay waterfront for vintage pieces of railroad and logging equipment. The nonprofit group is the Oregon Coast chapter of the National Railway Historical Society and was started in the early 1980s to help preserve their signature piece, the 1922 Baldwin steam locomotive No. 104. Old No. 104 was used for four decades in the forests of the region, hauling logs from Powers and Fairview. The group also has a 1949 diesel locomotive used at a local sawmill and paper plant, and they recently acquired a vintage Southern Pacific caboose that ran on the local lines for many years. They also have a variety of old logging and road-building equipment on display. (Courtesy Oregon Coast Historical Railway.)

In 1972, the Oregon Dunes National Recreation Area was officially established by Congress and is currently administered by the U.S. Forest Service. Among the best places to see Coos County's dunes are Horsfall Beach, named for William Horsfall, one of the region's early doctors, and along Highway 101 near North Slough. This image dates to the 1950s. (CCHMM 991-2.323.)

One of the nation's greatest long distance runners, Steve Prefontaine attended Marshfield High School from 1966 to 1969. In the 1970s, "Pre" held every American record, from the 2,000 meters to 10,000 meters. Expected to attend the 1976 Olympics, he died in a car accident in 1975 at the age of 24. The annual Prefontaine Memorial Run through Coos Bay honors his lasting achievements. (Author's collection.)

In 1917, a Portland-based company built a milk-condensing plant on pilings over the Coquille River at Bandon. Two years later, the Nestle Company established what was said to be the nation's largest and finest condensery at the site. They not only employed local residents at the plant, but also sent boats up the river to retrieve fresh milk from dairy farms. Six years later, Nestle closed the plant because of ongoing problems with the water supply. During the 1930s, Dalen Manufacturing produced battery separators at the site and, in the 1940s, the army stored vehicles and other gear in the building as part of the war effort. After World War II, the Moore Mill and Lumber Company took over the property, which became a popular local landmark. In 2001, the dilapidated structure was demolished. Today aging pilings mark the spot. (Author's collection.)

The modern-day version of Marshfield's Front Street is highlighted by a scenic waterfront boardwalk, which overlooks Isthmus Slough from central Coos Bay. In the distance, visitors can spot the site of C. A. Smith's Big Mill, which is still active but under different ownership, and they also can identify the waterway's junction with Coalbank Slough. The boardwalk features local history displays. (Author's collection.)

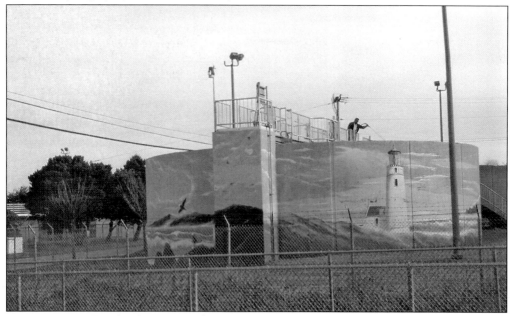

In recent years, Bandon has acquired a reputation for its fine collection of artists and writers. Painter Jack Champagne's scenic murals decorate exterior walls of shops, restaurants, hotels, and even Bandon's wastewater treatment facility and can be seen as far south as Port Orford, in Curry County. Champagne died in 2003, leaving his murals as a visible legacy to the region. (Author's collection.)

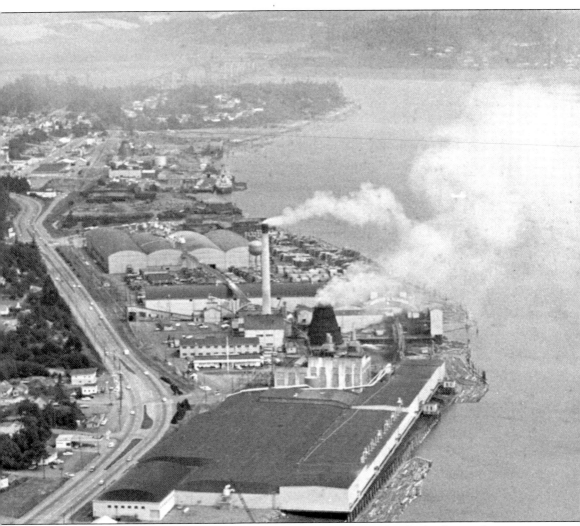

In 1908, the Weyerhaeuser Timber Company purchased 27,075 acres of timberland in southwestern Oregon and became one of three companies in Coos County (along with C. A. Smith and Menasha) to dominate the industry. Prior to opening their North Bend sawmill in 1951, Weyerhaeuser ensured access to their forests by building a network of roads and dredging the waterways. During the 1960s, the company expanded its production level, increased annual harvests, and began exporting timber to Japan. In 1989, they closed the sawmill, but maintained their paper mill site on the North Spit until 2003, when it also closed. In 1993, the Coquille Indian tribe purchased the North Bend site and reopened it two years later as the Mill Casino. The Port of Coos Bay is now in the process of purchasing Weyerhaeuser's lands on the North Spit. The Menasha Forest Products Corporation is still headquartered in North Bend but has recently been sold to a company based in Portland. (CCHMM 989-P51.)

# DISCOVER THOUSANDS OF LOCAL HISTORY BOOKS
## FEATURING MILLIONS OF VINTAGE IMAGES

Arcadia Publishing, the leading local history publisher in the United States, is committed to making history accessible and meaningful through publishing books that celebrate and preserve the heritage of America's people and places.

## Find more books like this at
## **www.arcadiapublishing.com**

Search for your hometown history, your old stomping grounds, and even your favorite sports team.

Consistent with our mission to preserve history on a local level, this book was printed in South Carolina on American-made paper and manufactured entirely in the United States. Products carrying the accredited Forest Stewardship Council (FSC) label are printed on 100 percent FSC-certified paper.

MADE IN THE USA